wild MAINE

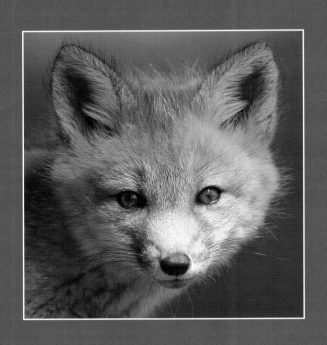

WILD MAINE

DISCOVERIES OF A WILDLIFE PHOTOGRAPHER

BILL SILLIKER, JR

DOWN EAST BOOKS

CAMDEN MAINE

ISBN 0-89272-630-X

LCCN: 20031100969

Printed in China. RPS

5 4 3 2 1

Down East Books

A division of Down East Enterprise, Inc.,

Publisher of *Down East*, the Magazine of Maine

Book orders:

1-800-685-7962

www.downeastbooks.com

FRONT COVER: *Wood duck drake in breeding plumage*

BACK COVER IMAGES: *Black bear, Atlantic puffin, Canada lynx, and harbor seal*

DESIGNED BY Harrah Lord, Yellow House Studio, Rockport, Maine

DEDICATION

The pursuit of wildlife photography requires patience and perseverance. It is also tremendously helpful to have an understanding spouse.

My wife, Maryellen, accompanies me on occasion, but more often keeps the dog company and the home duties done. Her trips to the wilds have made her aware of the difficulties involved in this profession of mine. They have also shown her how truly exciting an encounter with Maine's wild animals can be.

And so, for *her* patience and perseverance, I dedicate this special collection of favorite Maine wildlife encounters to her. I could never have experienced them without her support and understanding.

———————

CONTENTS

TRIBUTES **REMEMBERING BILL SILLIKER**
"The Mooseman" **9**

INTRODUCTION **AS WILD AS IT GETS**
Maine's Wilderness Mosaic **13**

CHAPTER ONE **PRIMEVAL BIRDS**
The Common Loon,
Symbol of the Wilderness **17**

CHAPTER TWO **BLACK GHOSTS**
The Surprisingly Abundant Black Bear **23**

CHAPTER THREE **BIRD ISLANDS**
Havens for Nesting Seabirds **29**

CHAPTER FOUR **GENTLE GIANTS**
Maine's State Animal—The Moose **35**

Eider and harlequin ducks float weightlessly on heavy
seas in one of Bill Sillker's favorite photographs.
(detail from left side of image)

CHAPTER FIVE **WINGED VISITORS**
*Birds that Summer—or Winter—
in Maine* **39**

CHAPTER SIX **THE STATE BIRD**
The Feisty Black-Capped Chickadee **45**

CHAPTER SEVEN **WATERFOWL**
Ducks and Geese **48**

CHAPTER EIGHT **UPLAND GAME BIRDS**
Wild Turkey, Grouse, and Woodcock **53**

CHAPTER NINE **IN THE PRESENCE OF FOXES**
*The Ubiquitous Fox,
Both Red and Gray* **58**

CHAPTER TEN **THE WILD CATS**
*The Elusive Bobcat, Rare Canada Lynx,
and Ephemeral Cougar* **63**

CHAPTER ELEVEN **OTHER FURBEARERS**
*Pine Marten, Beaver, Raccoon, Otter,
Mink, and Others* **67**

CHAPTER TWELVE **SEA MAMMALS**
Seals and Whales in the Gulf of Maine **73**

CHAPTER THIRTEEN **EAGLES FOREVER**
The Bald Eagle, Back from Extinction **79**

CHAPTER FOURTEEN **GRACEFUL WHITETAILS**
*Thriving in the Wild—and in
Our Backyards* **83**

CHAPTER FIFTEEN **SOME NEWCOMERS**
*The Coyote, Cardinal,
Glossy Ibis, and Others* **89**

CHAPTER SIXTEEN **GONE BUT NOT FORGOTTEN**
*The Gray Wolf, the Caribou, and
Other Missing Pieces of the Mosaic* **93**

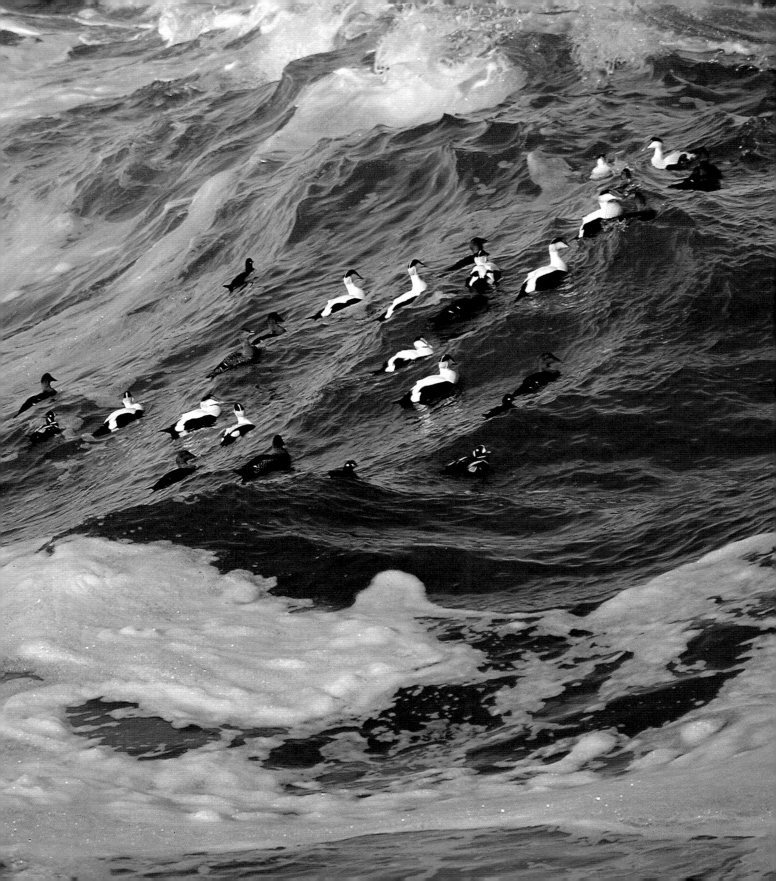

tributes

REMEMBERING BILL SILLIKER

"the Mooseman"

1947–2003

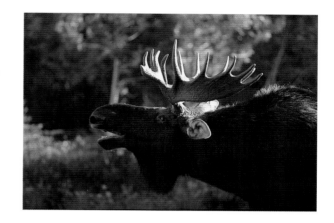

Bill was a devoted conservation advocate, whose primary tool was his camera. His moving images captured his deep love for Maine's wealth of natural landscapes and wildlife. Through his passion and his craft, he opened many eyes to beauty, moments, and places in Maine's natural world that they otherwise would not have seen, and he inspired others to use their talents to help preserve the natural world as well.

BROWNIE CARSON
EXECUTIVE DIRECTOR
NATURAL RESOURCES COUNCIL OF MAINE

When Bill served on the Non-game Advisory Board for the Department of Inland Fisheries and Wildlife during the mid-1990s, he was always thoughtful, enthusiastic, full of ideas, and supportive of conservation ideals. He continually worked to provide more wildlife-viewing opportunities for Maine people.

My wife, Sue, and I hiked into Sandy Stream Pond in Baxter State Park four years ago, and there was Bill with his entourage of students, photographing a cow moose from every imaginable angle. That is my "picture" of Bill Silliker in all his glory.

BUCKY OWEN
FORMER COMMISSIONER, MAINE DEPARTMENT OF
INLAND FISHERIES AND WILDLIFE

Early on during the times that Bill Silliker visited Baxter State Park, I had the opportunity to meet him on several occasions. We enjoyed discussing natural resources, and we shared a sincere desire to work together on issues of how to protect them.

At one point Bill asked if I would be interested in doing an on-camera interview at Round Pond during the winter months. He was preparing a video about the park. In the first scene, I approached from the

Eider and harlequin ducks float weightlessly on heavy seas. (detail from right side of image)

southeast on snowshoes, carrying pack and axe, and greeted Bill near the west side of the pond. On the day of the interview, we had about sixteen inches of new snow and the wind-chill factor was substantial. We had to keep our feet moving to prevent them from becoming chilled. The interview went extremely well nonetheless. The intensiveness of his questions and the sincere interest he maintained for the duration of that interview illustrated Bill's commitment to Baxter State Park.

From that time on, we talked on many occasions about the protection of Maine moose and the need to provide areas outside Baxter State Park where people can enjoy viewing this magnificent animal. Seldom do people visit our area without asking, "Where can I see a moose?"

Bill's dedication and personal interest—as demonstrated in his photography, his writings, and his publications—have inspired all of us as we share the natural beauties of Maine. We shall miss him, but can take great satisfaction in the results of his work, his friendship, and his cooperative approach to protecting our natural resources.

Buzz Caverly
Director, Baxter State Park

––––––––––

I came to expect it. The light on my telephone would be blinking as I stepped into the office. It would be a message from Bill having called late in the evening between connections at an airport somewhere in mid-America or very early in the morning from home as he packed, hurrying to make it to the jetport. He would be headed for the Baja Peninsula or a secluded marsh in Florida or a remote part of the Alaskan tundra.

Whatever the exotic locale, he would be trekking into the wild to photograph at close range the sea lion or the pronghorn or the elk or the wolf or the grizzly. Sometimes he was only headed up the Maine coast to make indelible images of eagles, osprey, heron, egrets, puffins, or seals. Very often he was on his way once again to Baxter State Park in his van to camp and to capture the intimate lives of deer and loon, wood duck, coyote, black bear, and, of course, to return to his favorite subject, the one he became known for, the one for which he gained the appellation "Mooseman."

It seemed Bill was always just heading out or just getting back. If he wasn't actually photographing, he was making a presentation at a wildlife photographer's conference or showing slides to a civic group or leading a moose-viewing tour, telling people where and how to photograph wildlife. But wherever Bill went and whatever he was doing, he would be sharing a rare brew of enthusiasm and commitment and respect for nature's creatures and their habitats.

I met Bill before all this, before photography had become a passion or, perhaps more accurately, before it became his means of expressing his passion for the natural world.

Bill and a group of neighbors were trying to save Goosefare Marsh in Ocean Park from destruction. A mammoth, and in retrospect bizarre, development scheme would have destroyed this scenic and

ecologically important wetland complex—replacing it with pavement and building lots far in excess of any reasonable expectations for the area. In those days Bill used his camera as a tool in assessing insurance claims, so it was natural for him to take it with him as he'd hiked out into Goosefare Marsh and to make some slides and to show them to others. But what astounded Bill was the impact his images had on the audiences. People saw the images and they understood what was at stake and they wanted to help save the wetlands.

Though it took some years for even Bill to recognize it, that was the beginning of a career that not only helped save Goosefare Marsh—with some help from Senator George Mitchell and The Nature Conservancy—but would over the years help dozens of conservation groups achieve similar success. However busy he became with assignments and books, he would always find a hole in his schedule to photograph an emerging project. The Bill Silliker slides in The Nature Conservancy's files, for example, are too numerous to count. Bill's photographs populate our publications and our presentations and our walls. From Goosefare Marsh to Big Reed Forest Reserve to Mount Agamenticus to the Saco River to the Katahdin Forest and so many more.

Just a few weeks before his death, Bill walked into the office unexpectedly with some sheaths of slides—images of bobcats, pine martens, loons, bears, eagles, and moose. He thought we could use them, he said, and we have; they are yet another part of his many and enduring contributions to conservation.

Bill was always seeking ways to further our mission to preserve native plant and animal habitats and the goals of other conservation and environmental organizations. That was why he'd leave those phone messages. An idea had struck him on the way to the airport and he wanted to test it out. "What if I did a book on the people who inspired conservation projects in Maine," he might begin, and he'd always end with something like: "Just an idea. Call me when you have a chance." And when we'd connect, he'd say "This will only take a minute," but it would be closer to an hour by the time we'd teased that idea out into another full-blown Bill Silliker project.

Bill was warm, thoughtful, and gregarious. Looking back on his books, calendars, articles, and thousands of compelling images, we can see he was also a highly productive professional. With all that he accomplished, my sense was that Bill saw himself as a supporter of these many causes. I hope he knew that we all saw him as a champion.

<div style="text-align: right">

KENT W. WOMMACK
EXECUTIVE DIRECTOR AND VICE PRESIDENT
THE NATURE CONSERVANCY OF MAINE

</div>

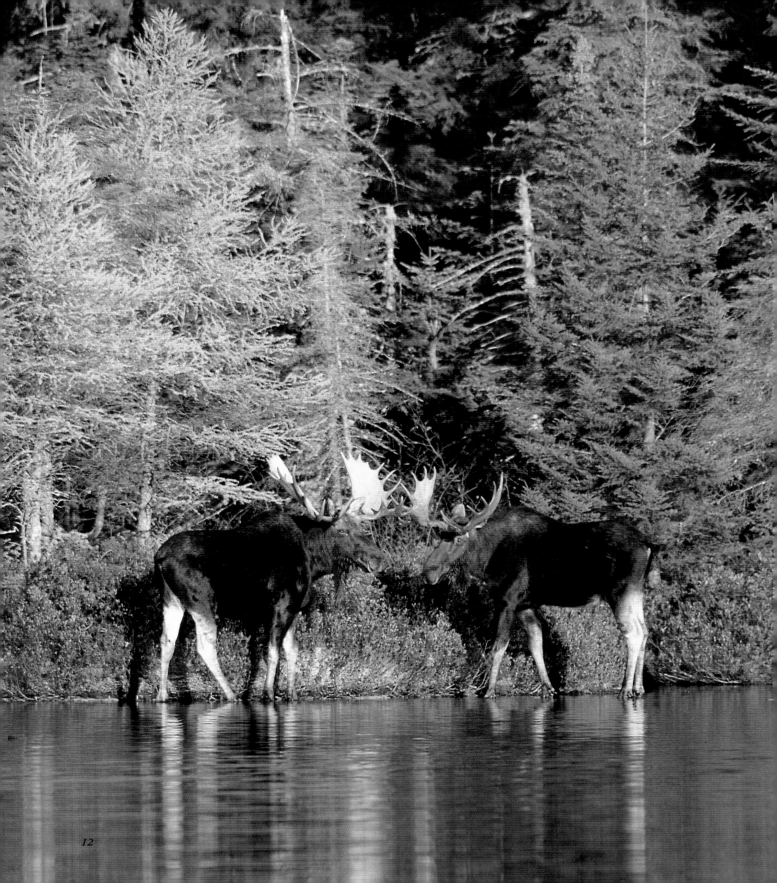

AS WILD
AS IT GETS

There was once a great mosaic, constructed of precious stones, jewels, and gold, exquisite in workmanship, full of history, and setting forth the laws of life, well-being and joy. That mosaic was broken, scattered and lost. No one knows exactly what it was like. But wonderful morsels are picked up from time to time in the dustbins, in the woods, on the highway, in the dens of animals, in the minds of men, in the dreams of children.

ERNEST THOMPSON SETON
North American Wildlife, VOL. 1, 1925

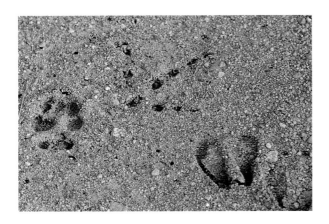

While the "great mosaic" of the place that we call Maine has been badly cracked, it has not been broken. And it is not lost. But its precious stones have been scattered enough that we can only imagine what it once must have been like.

A unique blend of remote and rugged geography, land ownership patterns, low human population, and Maine people's abiding respect for nature has protected the state's "exquisite workmanship" from the ravages wrought upon many of the once equally wild lands to its south. My book *Saving Maine: An Album of Conservation Success Stories* (Down East Books, 2002) tells the stories of how some of Maine's special places have been protected.

Wild Maine continues the theme, only with stories about wildlife. Few other states enjoy the diversity of wild species that Maine does today. The state's unique landscape, which includes more than seventeen million acres of forested upland, many mountains, thousands of lakes and ponds, miles of rivers and streams, and a coastline that jigs and jogs for more than five thousand mostly untamed miles (including some four thousand islands and tidal ledges), offers wildlife an extraordinary mix of habitats. Maine is also located at the northern edge of the range for some species, the southern end for others, making it a summer home for many and a

(above) A remarkable juxtaposition of coyote, turkey, and whitetail tracks on the sand at Swan Island.
(left) Moose are the most "charismatic" of Maine's wildlife for many people.

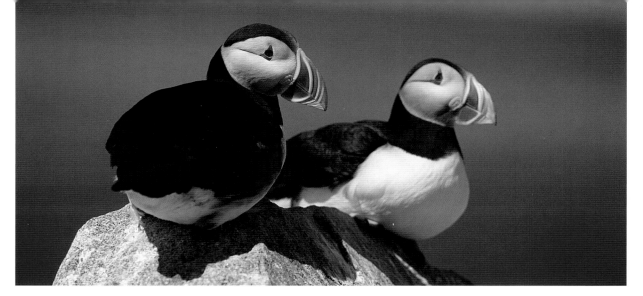

Atlantic puffins at Machias Seal Island

year-round home for more. Maine really does represent Seton's once-great mosaic. And with animals ranging from the moose to the Atlantic puffin, the harbor seal to the black bear, the common loon to the not-so-common lynx, Maine truly is about as wild as it gets in the Lower Forty-Eight.

This look at wild Maine will limit itself to birds and mammals. Because of the specialized equipment and expertise required—not to mention my own interests—I've mostly passed on photographing reptiles, fish, and insects. That's not to say that these other species aren't an important part of the Maine mosaic. Indeed they are. But to be most productive, wildlife photographers need to focus—literally—on one species at a time. Partly because I cannot do them justice, *Wild Maine* does not cover these perhaps less charismatic fauna.

That's also partly because this book is not intended to be a comprehensive guide to all the wildlife of Maine. If you're looking for such facts, you'll still find some good information on the species included here, but those who want primarily a guidebook will find many others that cover every species in the region. What *Wild Maine* is intended to be is a discovery of some of the morsels that are still out there—in the woods, in the dens of animals, in the wilds of Maine.

The discovery of what's still out there has so intrigued me that I left a well-paying career some years ago to become a professional wildlife photographer. My efforts to find and photograph Maine's amazing assortment of wild inhabitants over the years have led to some enchanting encounters and experiences. The stories of those experiences and a look at the animal species that provided them are what *Wild Maine* is all about. Perhaps through these words and images, the beauty and fascination of "what's still out there" will color your dreams as they have mine.

———————————

A black bear cub at Moosehorn National Wildlife Refuge

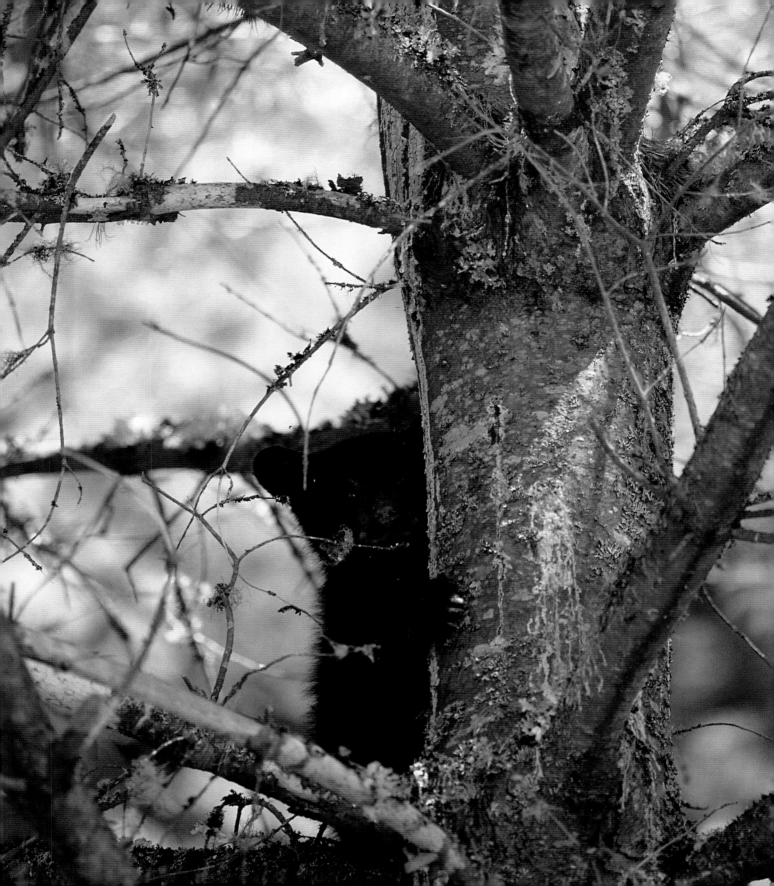

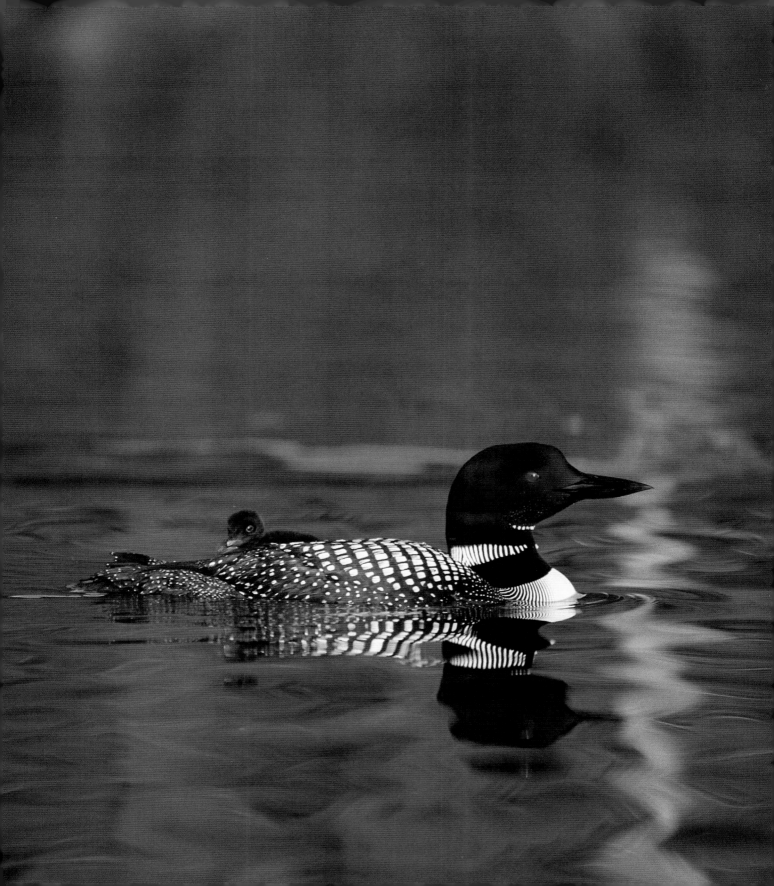

chapter one

PRIMEVAL BIRDS

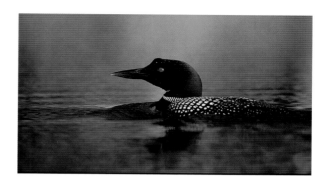

Who is this Gladys?" asked my wife one Fourth of July as we hosted some friends for a backyard barbecue. "She just called and said, 'Tell Bill the chicks are ready!'"

When is a loon chick ready to meet the world? The one riding on its parent's back in the picture opposite was still in its egg the night before this photograph. How did I get so lucky as to be there for such a moment?

Loons tend their nests almost constantly during the twenty-eight-day incubation period, not only to keep the eggs warm but also to protect them from predators. While parents occasionally leave the eggs unattended for a short time, any interference that drives them off the nest places the eggs in great jeopardy.

Once the chicks have hatched, the parents take them to the water as soon as possible. Loons walk with great difficulty and so feel much safer in the water, where they are strong, fast swimmers. A newly hatched chick rides atop one of its parents for most of its first week. After that it continues to ride for a few hours each day for several weeks. When it grows too large to

go piggyback, it will swim along behind and wait patiently on the surface while its parents dive briefly after food.

Riding on an adult provides the new chick with both warmth and protection. Death can come quickly to a loon chick temporarily abandoned by its parents. A snapping turtle might gobble it up from below. An eagle or, more commonly, a gull might strike from above.

Loon parents generally stay in shallow and sheltered waters with minimal wave activity during the first several weeks of a chick's life. They also stay close to shore, perhaps to enable their offspring to hide along the edge should danger threaten.

The equally entertaining pursuits of wildlife watching and wildlife photography have encouraged me to become a better naturalist. Knowing as much as I can about the species I want to view makes it easier to know not only when and where to find them, but also how to observe them without interfering in their lives.

Building trust helps a lot, too. In this case I needed the trust not only of the loon family, but also

(above) For many people, loons are symbols of the northern wilderness.
(left) A parent's back is the safest resting place for a loon hatchling.

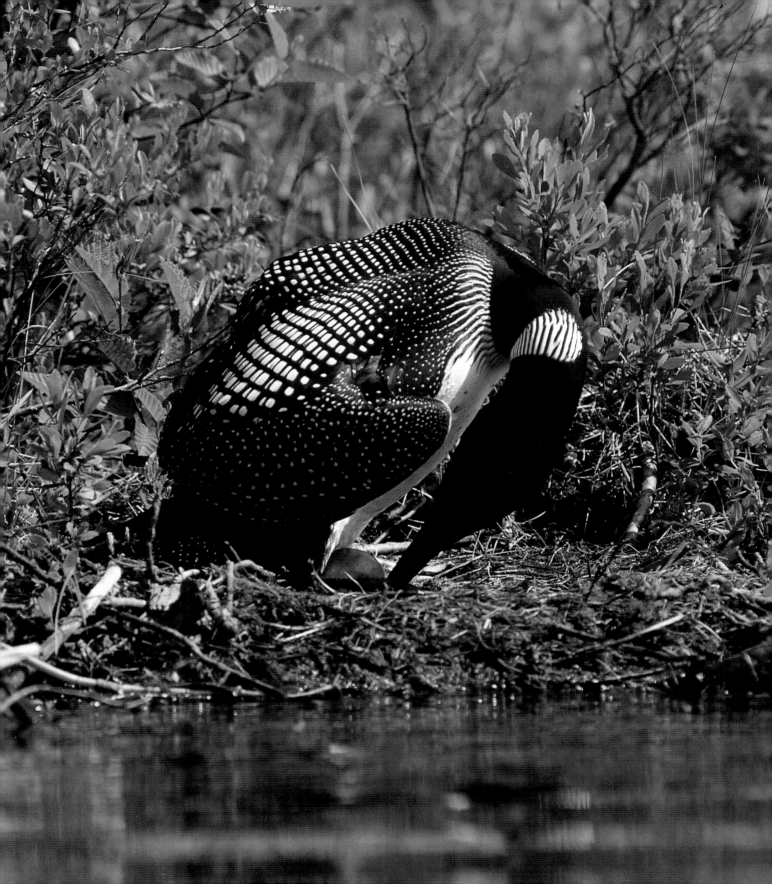

of the rangers who monitored the pond where the birds spend their summers.

Loons typically mate for life and return to the same pond or lake, even to the same nest location, year after year. My experience of the past several years said that this pair would likely nest on a small island in the pond and would hatch out a chick or chicks in late June or early July. The rangers agreed to call when they first saw an egg at the nest. Knowing the incubation period made it pretty easy to guess when to be around for the blessed event.

Being there for a sensitive moment in the life cycle of any animal also requires respect for nature. Because I'd proven myself to these rangers by taking care around wildlife, most especially the sensitive loons, they felt comfortable telling me where the nest was and when they'd first spotted the eggs that year—hence my July 4 phone call.

The trust of a loon is a bit more difficult to achieve. Some folks might attempt to paddle right over to the loons' nursery area—usually a sheltered cove where they keep their chicks for the first several weeks. Yet such a direct approach can not only prevent getting close enough for a good look at the loons, but can also cause them irreparable damage. Ethical wildlife photographers avoid interfering with the lives of their subjects. They use long telephoto lenses and either hide from the animals or work with them for days to gain their acceptance.

I paddled just to the edge of the nursery area and stopped there to watch the loons going about their business. Using six hundred millimeters of lens reach—the equivalent of twelve-power binoculars—permitted me to photograph the birds from a distance for several hours, netting me some decent pictures.

When did I move closer to get the photograph that opens this chapter? Never. Because I'd been respectful and shown them that no harm was meant, the loons eventually came over to visit me.

Who knows? Perhaps they wanted to show off their new baby.

THE LOONS OF MAINE

Loons are one of the oldest extant species, dating back at least twenty-five million years. Actually, five species exist today: the red-throated, the Arctic, the Pacific, the yellow-billed, and the common loon. While red-throated loons will overwinter in Maine's coastal waters, the common loon is the only one that nests in the lakes and ponds of our northern forests.

Common loons inhabit Maine lakes and ponds in spring, summer, and fall, migrating to the coast or farther south for the winter. The loon parents leave

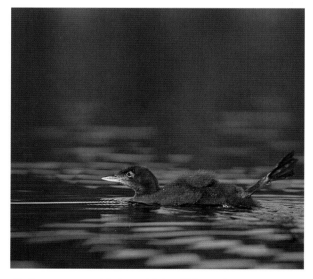

By late autumn, this loon chick will be on its own.

Loon nests, built near the shore, are vulnerable to immersion caused by the wakes from passing powerboats.

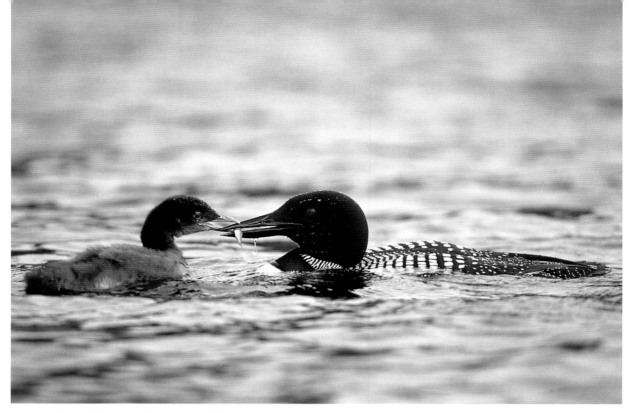

Loons feed on fish, primarily, plus a smaller amount of aquatic invertebrates.

first in the fall, often after gathering with other adults for a few days before dispersing to their winter range. Most juvenile birds follow shortly afterward, usually flying first to larger bodies of water, where they also might gather with other newly independent young loons. Sooner or later the juveniles find their own way to the coasts or to climes where water does not freeze. Any that don't will perish.

Historical records indicate that these birds have been common summer residents of interior Maine for as long as anyone knows. Common loons probably enjoyed almost every Maine lake and pond large enough to support them for millennia before development and the other pressures of civilization forced them out.

Both Native Americans and the European settlers who followed once hunted loons. It's noteworthy that in *To Katahdin,* a true account of the 1876 adventures of four young men in the Maine woods, author George Sewall twice lamented not being able to shoot loons they had encountered: once because the guns weren't unpacked; the second time because it was a Sunday.

Finally protected by the Migratory Bird Treaty Act of 1918, the common loon now enjoys celebrity status as an almost mystical resident of the northern wilderness. In the minds of most people, the presence of nesting loons marks a place as being still wild.

Fieldwork by wildlife biologists with the Maine Department of Inland Fisheries and Wildlife and the

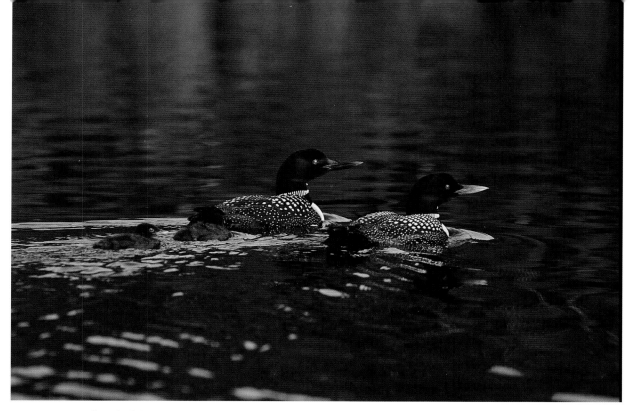

Loons raise one brood of chicks each year, usually laying two eggs per clutch.

folks at Maine Audubon Society indicates that more than 4300 common loons live in Maine today. That's actually a significant increase over Maine's loon population of the 1980s. But it doesn't mean Maine will continue to enjoy loons forever. On the contrary, the common loon, one of nature's longest-lasting species, is significantly threatened by modern society. As "progress" has come to wild Maine, so too have hazards never before faced by these ancient birds. Development of shorelines, anglers' use of lead sinkers (which loons ingest), waves from powerboats and personal watercraft that wash over shoreline nests, and pollution are among the major concerns.

The worst of these may be the mercury that gets concentrated in the flesh of fish, the loon's primary food supply. Wind-delivered from power plants in the Midwest and trash incinerators closer to home, mercury is building up in the fish of Maine's lakes and ponds at an alarming rate. Biologists fear that if the trend continues, someday—not many years from now—the call of the loon that has so pleasingly haunted wild Maine's lakes and ponds for so long may disappear forever.

———————

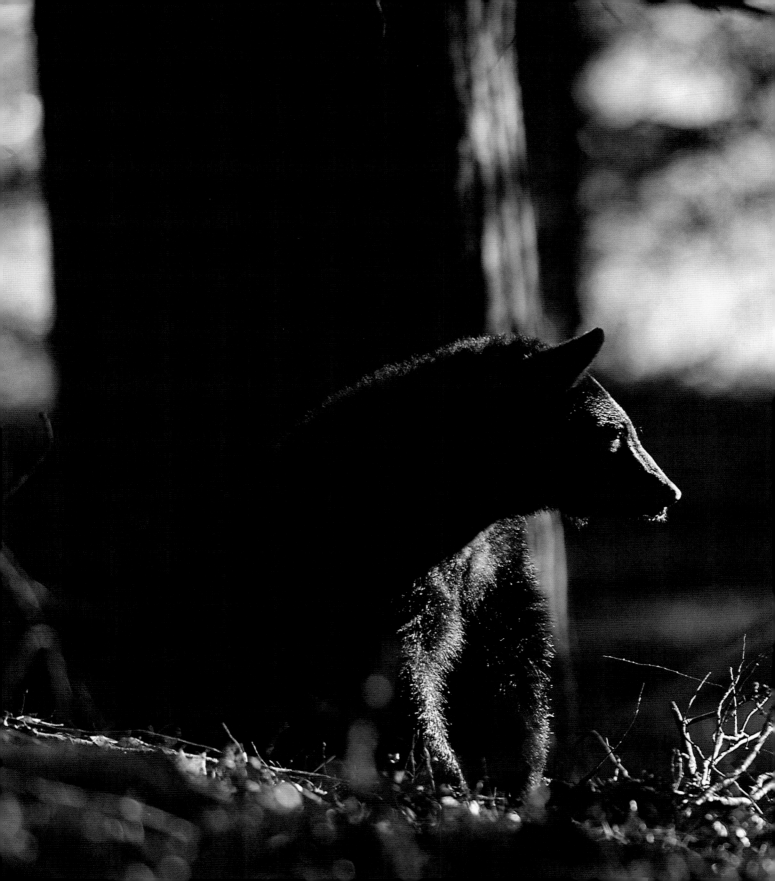

chapter two

BLACK GHOSTS

When William "Butch" McCormick, of Wilton, stood atop a mound of snow on the side of a ridge in the woods of Franklin County and called his beagle, he never expected a black bear to show up as well. Especially not in February, when these animals are typically snoozing away the winter. Butch's experience—or more appropriately that of his dog, Dodger—provides fascinating insights into the life of the seldom seen black bear.

It started on a Thursday, as Butch worked with his dog in the woods of Perkins Township in western Maine, training him to hunt rabbits. The beagle wore a radio collar so Butch could track him as he chased after scents. Sometime before noon, Dodger took off up a ridge, and Butch couldn't find him. While the radio worked fine, Butch couldn't "cut a track" on the dog. He only knew that his hound was up on that ridge, in a fixed position. He finally had to quit searching for the day when it got close to 10 P.M.

On Friday, Butch and his son searched for the dog, again without success. When they went back on Saturday, they found Dodger's tracks and followed them to a mound from which the radio signal seemed to be coming. When Butch called, Dodger popped out from under the snow-laden brush. But just as the dog emerged, a black bear grabbed his hind leg in its mouth and pulled him back!

Butch left the den and came back on Sunday with a game warden. When the warden determined that this was a female bear with newborn cubs, he decided extra help was needed.

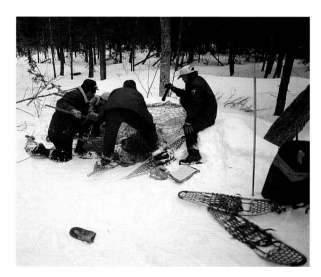

The Maine Bear Team works to retrieve Dodger from a bear's den. Normally, this sow and her cubs would not wake and leave their den until mid- to late April.

Black bears may live as long as thirty years in the wild. In Maine, they are indeed usually black, but in western portions of North America some individuals may be brown, gray, or even white.

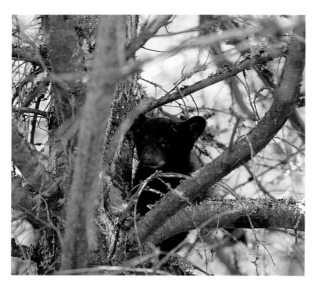

Bear cubs remain with their mothers for sixteen to eighteen months. This one was photographed at Moosehorn National Wildlife Refuge in Washington County.

Sandra Ritchie, then a seventeen-year veteran biologist with the Maine Department of Inland Fisheries and Wildlife, joined the rescue party that set out early on Monday. At first, when she looked in under the edge of the brush-pile den, she saw only the black bear mother. Then the sow rolled in her sleep, and Ritchie caught a glimpse of two little cubs and the beagle cuddled up beneath her.

Another biologist attempted to jab the mother with a dose of the tranquilizer the Maine Bear Team uses when surveying cub numbers in a sampling of den sites each winter. It proved to be too difficult a task: The biologists didn't want to risk accidentally jabbing one of the cubs or the dog with the dosage required for the much larger adult bear.

After three days of sleeping with the enemy, the beagle had to be terrified. Still, the sound of people outside the den must have offered hope. Sandy Ritchie described the situation: "The dog would try to come out, whining and barking and crying. But the bear would reach up and gently take his leg in her mouth and pull him back into the den."

Ritchie finally saw a chance when the dog struggled to get out again. She grabbed Dodger by the collar before the sow could pull him back, and ran from the den. The bear climbed out the other side and stared at the group of people. She sauntered off a ways, then walked back and forth a few steps while looking back again. Ritchie figured that the bear thought they'd taken one of her cubs.

Finally, the unhappy mother wandered off into the woods, and the grateful dog happily rejoined his master with nothing to show for the experience but a tooth mark in his collar and a few patches of hair missing from his ears—probably from the suckling of the cubs, the biologists speculated.

But the biologists now had another concern: the possibility of abandoned bear cubs. The rescue team pulled back and waited, but when they checked the den a few hours later mother had not come back. As the day grew longer and colder and the cubs began to bawl and fidget, Ritchie got a space blanket from her pack and borrowed two old wool blankets from someone else to cover the cubs for the cold winter night.

Fortunately, when the wildlife management team checked the den the next day, they found mother bear back on the job.

Did the bear adopt the little beagle, thinking it was one of her own cubs? The wildlife biologists think

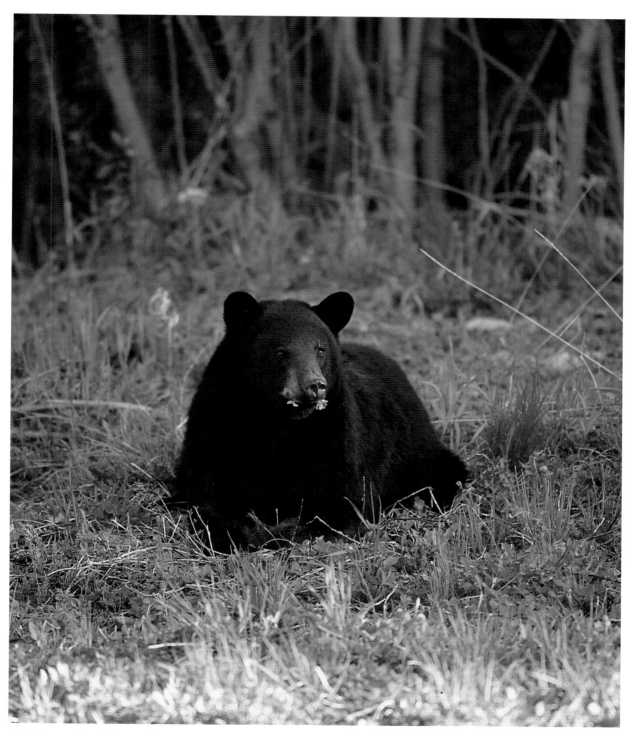

In Maine, a female bear will range over a six- to nine-square-mile area. Males' territories are larger and may exceed a hundred square miles, according to the Maine Department of Inland Fisheries and Wildlife.

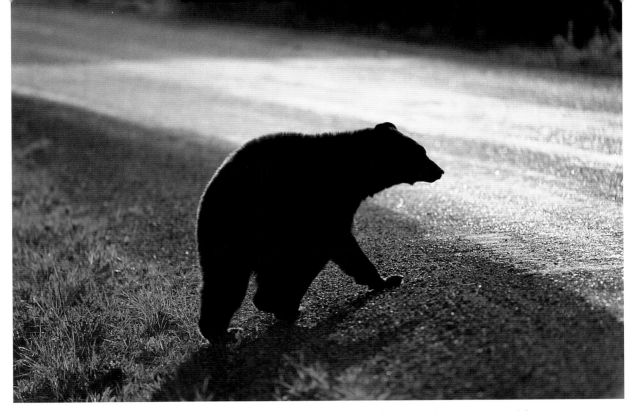

Bears can adapt readily to human presence, and they sometimes raid bird feeders, trash containers, and farm crops.

so. And they figure that if they encounter any orphan cubs in the future, this female would make a good candidate for an adoptive mother. As one biologist put it: "If she'll adopt a beagle, she'll take in another bear's cub."

THE BLACK BEARS OF MAINE

Biologists estimate that as many as twenty-three thousand black bears live in Maine today—more than in any other state east of the Mississippi River. So why do we so seldom see them?

Black bears are secretive animals. As one Maine wildlife biologist described it, they "ghost" through the woods. Accounts from early explorers of the Maine woods suggest that bears have always been so

retiring. Partly because of this, no reliable estimates exist of historical black bear populations in North America—let alone in Maine. But "the bear" that colors many of the tales and legends of the original peoples and the early European settlers of North America is the black bear. Much more widespread than either of its two distant relatives—the brown bear, or grizzly, and the white, or polar, bear—the black bear once inhabited most of North America and still does.

It is also truly the American bear. Black bears do not inhabit any other continent, while the other two bear species found in North America do.

You're most apt to encounter a black bear at a food source. And contrary to some of the black bears

of fiction, these animals feed more often on fruits, nuts, and berries than on animals—or people.

That's not to say that a black bear can't be dangerous. Of all the wild animals living in Maine today, this is the species most capable of hurting you if you encounter one on the wrong day. It's a fact that black bears injure more people every year than the brown bears—the grizzlies—do. That's partly because they outnumber grizzlies by at least fifty to one. It's also because black bears cover a much wider range. Populations of black bears are still found in most large wooded areas of the lower forty-eight states and Alaska, as well as across most of Canada, while brown bears live in only a handful of western states and provinces.

Those who think it's alarmist to be wary of a black bear should first consider that a single animal killed three teenage boys in Algonquin Park, Ontario, on May 13, 1978. But before the fear factor keeps you from enjoying the Maine woods, you should also know that your chances of being killed by lightning are far greater than your chances of being mauled by a bear. It just pays to have respect for black bears and what they can do. Enjoy them for the marvelous wild creatures that they are; don't fear them.

When you hike near natural food sources, be aware that you might encounter a black bear. Make a little noise, and you'll probably never see one. Bears have a great sense of smell and very good hearing, as well as reasonably good eyesight; it's not that easy to get close to one.

The best way to avoid black bear problems is to follow good bear country etiquette. Store your food in plastic bags, putting these and your cooler in the trunk of your car or cab of your truck, not in your tent or lean-to. The rules at state parks and other campgrounds in bear country were written for a reason. It's wise to follow them.

And what if you want to see a black bear in the wilds of Maine? If you're quiet and patient, and go to the right places long enough, sooner or later you'll be rewarded. Of course, you might just get a beagle to help you track down a bear—but that's not a highly recommended method.

———————

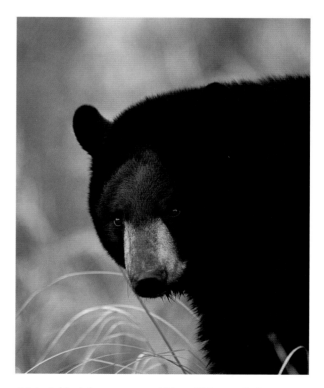

Maine's black bears average 100 to 400 pounds for females, 250 to 600 for males, yet these large forest dwellers are rarely seen.

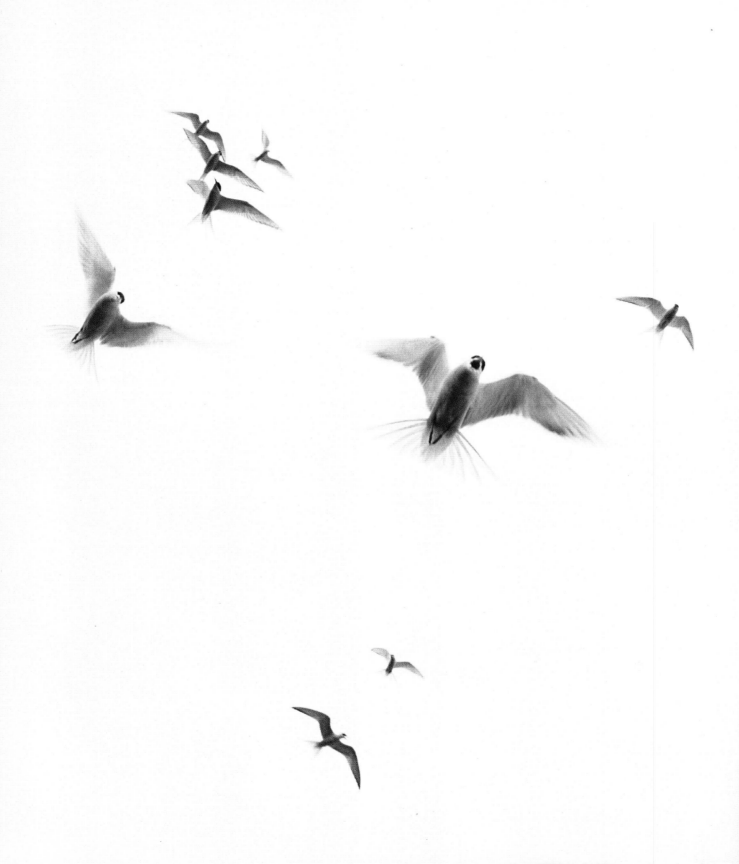

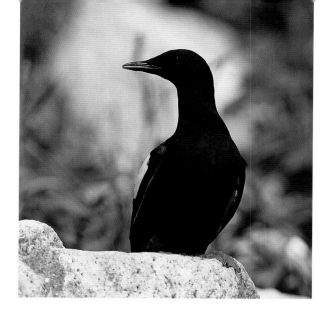

chapter three

SEA BIRDS

There are great colonies of seabirds on many of these islands that lie scattered variously from the Bay of Fundy, whose tides are the greatest in the world, to the calmer waters off the serene and sandy shores of southern Maine. And it is here in these wild colonies that bird enthusiasts are given opportunity to observe closely the home life of many of our most fascinating birds, providing living proof that, if intelligently protected by man, birds will once more fill our ears with natural music and our eyes with wild beauty.

HELEN GERE CRUICKSHANK
Bird Islands Down East, 1941

BIRD ISLANDS

If you ever have the chance to visit a colonial seabird nesting island in the Gulf of Maine during the breeding season, the first thing you'll notice is the incredible din. Depending on the species present and what's going on, the variety of bird voices can sound as melodic as a symphony or as crazy as a sampling from bedlam.

Terns particularly chatter away. They are constantly either talking to their mates, calling to their chicks, or warning their neighbors not to get too close. Add the merry cries of laughing gulls—an appropriately named bird if ever there was one—sprinkle in an occasional call from a herring gull or perhaps even a guillemot, and top it off with that strangest of bird sounds, the chain-saw rasp of the puffin, and you have a soundtrack matched by little else in life.

Birds covered Petit Manan Island, located off the

(above) A black guillemot's feet and the inside of its bill are both bright red during breeding season, when guillemots are most likely to be seen from shore. In Maine, these birds are at the southern edge of their range. (left) Circling, calling terns protect their nesting area at Petit Manan National Wildlife Refuge.

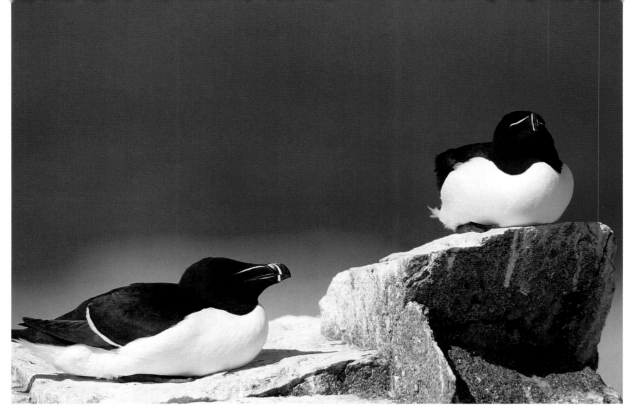

Razorbill auks nest in sheltered crevices on remote cliffs, laying a single egg. Chicks leave the nest after only eighteen days, fluttering (or tumbling) down to the water, where the parent birds continue to feed them until they are able to fly.

coast of Machias, as far as the eye could see on a July day several years ago. I'd landed to do photography in cooperation with the Petit Manan National Wildlife Refuge. It seemed that every rock, nook, or patch of sea grass held a bird!

Arctic terns nested here, common terns over there. The endangered roseate terns seemed to prefer nesting in small groups of their own kind surrounded by colonies of other terns. The laughing gulls occupied their own turf in the grassier center of the island, ringed by the nesting terns. Atlantic puffins stood on the outer rocks overlooking the sea, while their stranger-looking cousins, the razorbill auks, mingled among them. A few murres sat on the pink

granite rocks and soaked up the sun, with an occasional guillemot joining them. Eider broods worked the edge of the tide, which carried food for both mothers and youngsters.

The sight of them all—and particularly the sound of them all—reminded me of Helen Gere Cruickshank's *Bird Islands Down East*. In that classic book she described the puffins, terns, laughing gulls, and others on the islands that she and her husband, Allan Cruickshank, visited while doing conservation and photography work for the National Audubon Society during the 1930s.

Everywhere I looked, I saw birds. And most of them—even, at times, the usually quiet puffins—

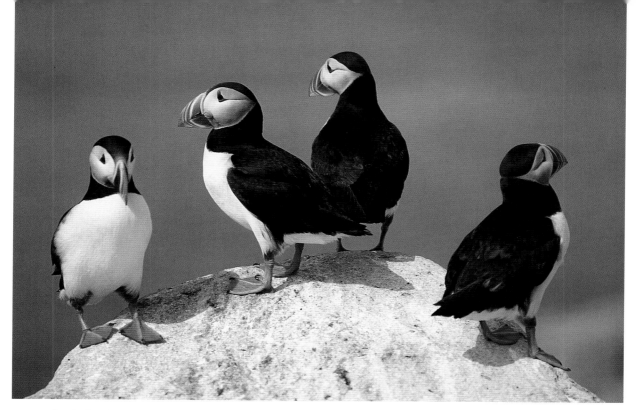

Except for the brief season when they are tending chicks in their underground nests, Atlantic puffins spend all their time at sea. Puffins are small members of the auk (alcidae) family of sea birds.

contributed to the endless concert. That's why it seemed so strange when all of that sound stopped in one giant *whoosh.* Every bird on the island—thousands of them—had taken to the air at the same time. It was as if someone had turned on a large fan to suck them off their nests and into the sky.

I was still pondering how to best photograph the spectacle when I spotted the peregrine falcon. It was flying toward the lighthouse with an entourage of angry seabirds on its tail. Now I could hear birds again—this time screaming in chorus at the intruder.

The falcon abruptly switched tactics and flew straight up the side of the old lighthouse, then turned on a dime to dive toward the island. It all happened in

a few wingbeats. I watched without being able to photograph any of it: The window openings in the researcher's blind didn't permit moving a big lens to follow such action, and a stick held the door jammed shut.

And so I have only a memory of the event. But sometimes a memory is enough, even for a wildlife photographer.

THE SEABIRDS OF MAINE

Colonial nesting seabirds once inhabited a number of islands along the Maine coast. Historical records indicate that the Native Americans exploited some of this resource, but the real impact on these birds came

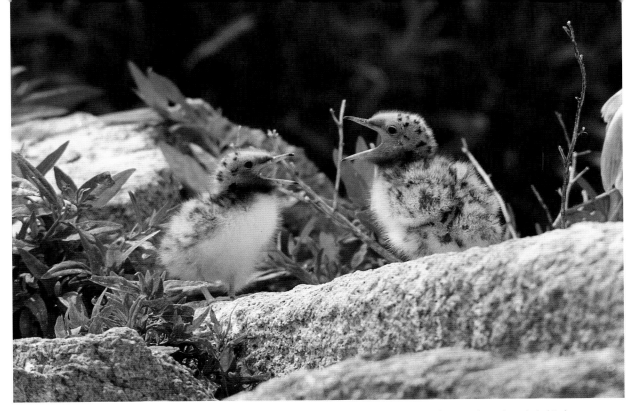

Tern chicks and eggs are both beautifully camouflaged—their best protection from predators when the adult birds are not nearby to defend them.

with the colonization of the New World by European settlers. Eggs were taken for food. Larger birds, including puffins, were shot for their meat. Development significantly affected many nesting islands, and the introduction of cats and dogs resulted in the further decline of their usefulness for seabirds.

Human thoughtlessness during the eighteenth and nineteenth centuries nearly extirpated most of the seabirds that help make the Maine coast such a special place. Several species actually did become extinct, including the great auk, a flightless relative of the puffin.

The final onslaught, which nearly wiped out the more delicately feathered species, was plume hunting. Tern feathers in particular were prized additions to

ladies' hats; in some cases a hat featured an entire bird. Had it not been for the passage of migratory-bird protection laws and their enforcement by Audubon wardens and a handful of environmentally aware lighthouse keepers, we might have lost all of our coastal seabird populations in a matter of years.

But merely stopping the exploitation was not enough to permit the recovery of the seabird species that historically enjoyed the islands along Maine's coast. Human intervention was required as well.

Awareness of both the direct and indirect human impacts on seabirds has in recent years led to creative efforts to help them return to their nesting islands. The National Audubon Society and the U.S. Fish and Wildlife Service today actively manage a handful of

nesting islands, including some that have been protected with the help of conservation organizations such as the Maine Coast Heritage Trust and The Nature Conservancy.

And with each passing year, increasing numbers of seabirds return to the coast of Maine to raise their young. As of this writing, some one hundred twenty thousand pairs of colonial nesting birds—including puffins, several tern and gull species, eiders, guillemots, razorbills, cormorants, and others—nest on more than three hundred fifty Maine islands each year.

Perhaps the most fascinating species is the Arctic tern. These birds leave their Maine islands in August to fly across the Atlantic, then head southward down the coast of Africa to summer in the waters of the Antarctic Ocean. That's the longest known migration of any species—a round trip of some twenty-two thousand miles. But what's more amazing is that these birds return year after year to nest on not only the same island, but also the same patch of open ground. May we have the wisdom to keep providing safe places for them as they continue to take their place in Maine's grand mosaic.

———————

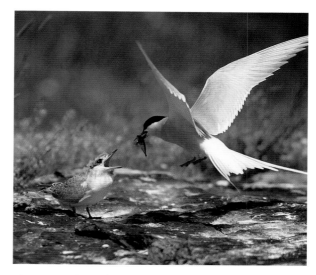

Arctic terns leave their northern breeding grounds in the fall and spend the rest of the year in Antarctic waters.

Robin-sized Leach's storm-petrels can be seen offshore in the summer, hovering just above the wave tops as they search for small fish. Although they do nest on some Maine islands such as Eastern Egg Rock, these secretive, nocturnal birds are almost never seen while on land.

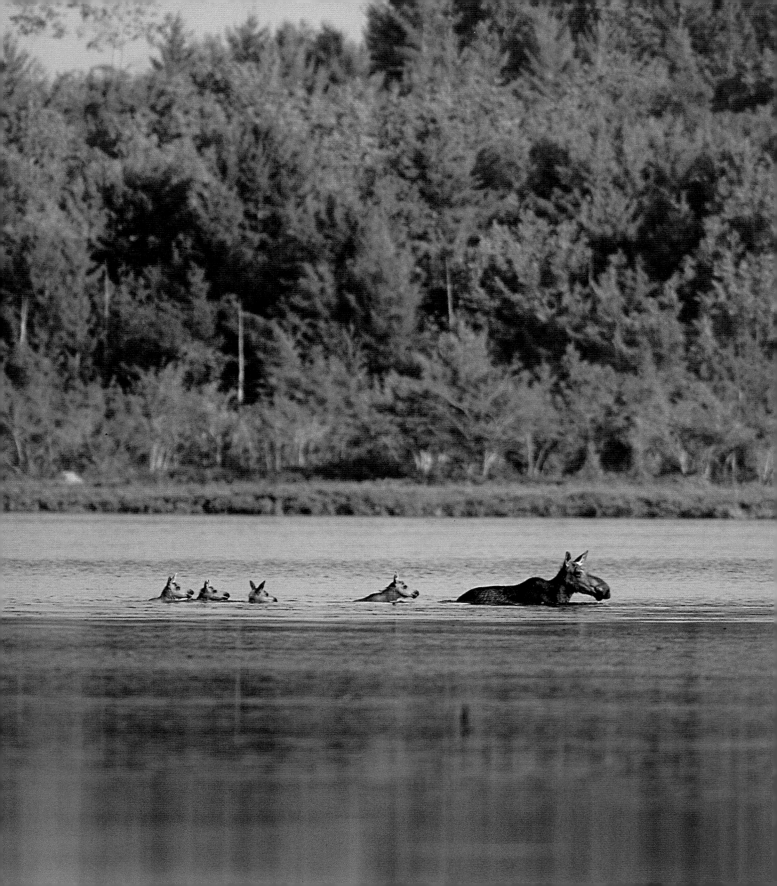

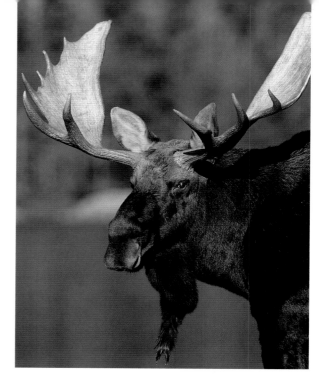

chapter four
GENTLE GIANTS

The photogenic Maine moose. Individuals of the eastern, or taiga, subspecies found in Maine are not quite as large as their Alaskan cousins, but they're impressive nonetheless.

I
f you ask biologists whether one moose will adopt another moose's offspring, they'll probably tell you: "Probably not."

And that's probably the best way to answer that question. Sighting a mother and calves together im-plies that they are kin. But, without DNA testing, how can a biologist determine for certain whether any particular moose calf belongs to any specific cow?

It is well known that moose are among the most protective mothers in nature. Those who study moose behavior can attest that moose are aggressive defenders of their offspring. They tolerate no other mammals near their babies—including other moose calves. And so the conventional wisdom holds that moose won't adopt.

But when asked about the likelihood that a moose could have quadruplets, biologists acknowledge that this also begins to tax the conventional wisdom.

Past reading and many personal observations of moose cows had already informed me that they seldom have triplets, let alone quadruplets, so how to explain the four calves that had been seen in the area for two weeks before I made the photograph on the facing page? My reading and fieldwork also strongly suggested that one cow moose would not readily adopt another's offspring. So I asked some experts:

Was this a rare case of adoption, or an even more rare case of a quadruple moose birth?

Dr. Vic Van Ballenberghe, who has studied moose for the USDA Forest Service, Alaska Department of Fish and Game, and other organizations for some thirty years, answered my question this way: "A few years ago at Tangle Lakes, Alaska, there was a cow with five calves. The conventional wisdom is that triplets are the max but very rare—I have seen three sets at Denali in 23 years. Cows with more than three have adopted others, either orphans or strays. So, your case of quads wasn't born to the same cow—but in nature, almost anything is possible."

Dr. Vince Crichton, a moose biologist with the Wildlife and Ecosystem Conservation Branch of the

Were all four calves the offspring of this single female? It's unlikely but possible.

Manitoba government for many years and editor of the *Alces Journal's* newsletter, the *Moose Call,* responded: "We had a similar photo of a cow with four in an earlier version of the *Moose Call*—some of my peers say it is impossible and that she must have adopted one. Frankly, I believe that it can occur—I have seen three on numerous occasions, and there was a case in Finland last year where a cow gave birth to seven, but none survived."

The mother moose I photographed led her entourage of four young calves close to a solitary cow that was already feeding in the pond that evening—unusual behavior, since, as noted, most moose cows don't take kindly to having any other moose near their youngsters. While there may be territorial food-protection reasons for this, the most likely explanation is that mother moose worry about their youngsters

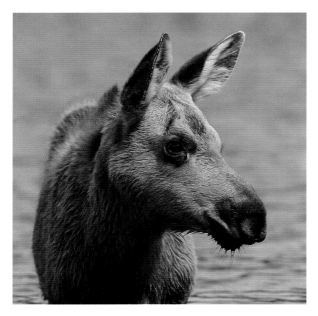

A calf at four to six weeks of age.

accidentally following another moose out of a pond.

And that's exactly what happened on this day. One calf wasn't paying attention when the rest of the family left, and mistakenly attached itself to the apparently barren cow. The mother and the other three siblings never looked back as they headed into the woods on the side of the pond they'd come from. The fourth little moose learned of its error only when it swam after the wrong cow and she ran it off on the opposite shore. When last seen, it stood bewildered on the far shore, with neither cow in view. Hopefully, its mother found it later.

And which cow moose would that be?

Only the moose know for sure.

THE MOOSE OF MAINE

The subspecies of moose found in Maine grows to a massive size. In fact, they are the largest land mammals in the state. Mature bulls typically weigh one thousand to twelve hundred pounds, and a few might reach fourteen hundred. Cows usually range from seven hundred to nine hundred pounds. A full-grown moose runs about ten feet long and stands seven feet at the shoulders.

But most moose have a calm demeanor and do not threaten humans who give them the space that their size deserves. The moose you *do* want to defer to are bull moose in the mating season (September and October) and cows with calves, especially in spring and summer.

It's worth noting that except during the mating season, bulls have no close contact with the females or with their own offspring. In fact, except during the rut, or mating season, bull moose avoid conflict with

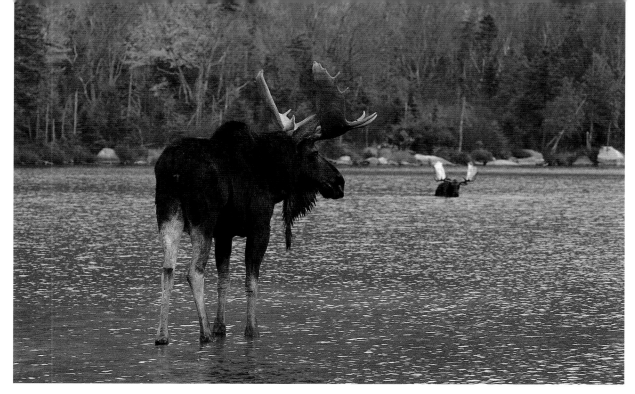

Two bulls size each other up. Dominance is determined as much by size and attitude as by actual antler-to-antler combat.

mother moose for their own safety. That should tell you something about trying to get too close to a moose calf!

Moose occupy most of the northern half of Maine today, and some even live in our southernmost counties. The Maine Department of Inland Fisheries and Wildlife estimated the 2002 Maine moose herd at between twenty-five thousand and twenty-nine thousand animals.

Of the early Maine explorers, the first to describe moose was Samuel de Champlain—in reports of explorations that began in 1603. This has led some historians to speculate that moose are fairly recent colonizers of this region, and perhaps of the entire Northeast. Jacques Cartier, who apparently never got as far south as Maine, made no mention of moose in the journals of his 1535 explorations up the St. Lawrence River to what is now Montreal. In fact, the earliest reference to moose in the region may be that of Lescarbot, who explored New France in the early 1600s and included a likeness of a moose on a map of Port Royal, Nova Scotia, in 1609.

Later historical references to moose, including those of English author and adventurer John Josselyn in 1672 and others from the 1700s, confirm that moose flourished in Maine through the middle of the nineteenth century. Then a combination of excessive hunting, poaching, and habitat change as forest was converted to farmland resulted in a significant decline in their numbers. Biologists estimate that as few as two thousand moose remained in the state by the early 1900s.

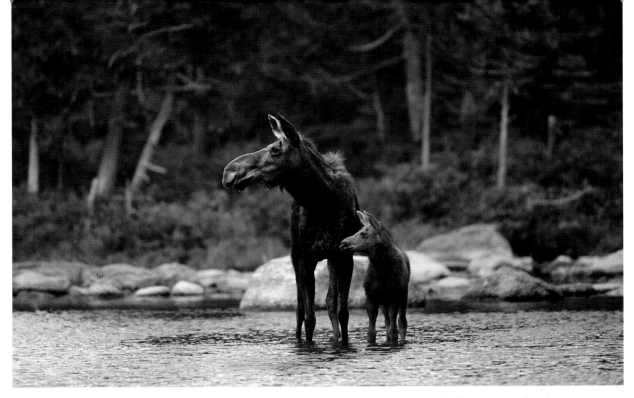

Moose are known to be fiercely protective mothers. Calves are born in May and stay with their mothers for about a year.

As a result, hunting seasons on moose were closed entirely from 1936 to 1980. A major habitat change also took place during this time, with many areas—including acreage that had once been clear-cut—returning to forest, thus regenerating food supplies for moose. By the mid-1980s Maine's moose herd had burgeoned to an estimated twenty-five thousand.

And although the Maine Department of Inland Fisheries and Wildlife hasn't really "counted" the moose herd since the 1980s, estimates based on hunter success rates, hunter surveys, and moose–vehicle accident statistics suggest that Maine's moose population remains at 1980s levels today.

Some wonder if these numbers aren't a bit optimistic—in recent years moose have been less frequently seen. Still, that's probably due to a combination of factors, including more wary behavior due to increased hunting pressure, and thick forest growth blocking the animals from the view of moose-watchers.

And while it's never easy to do an accurate census of any wildlife population, one thing is certain: We must take care with this unique species so that future generations can enjoy this most magnificent inhabitant of wild Maine.

———————

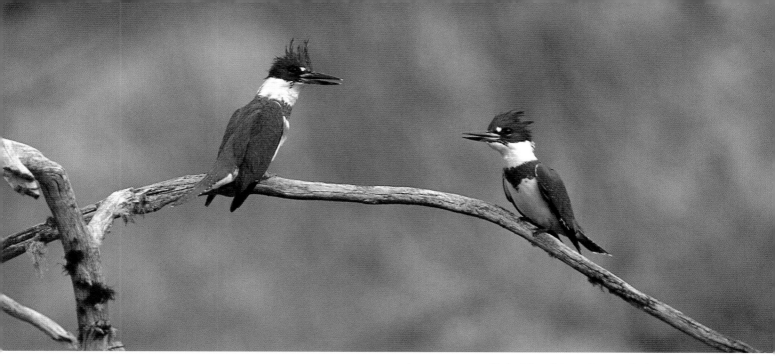

A courting pair of belted kingfishers photographed at Moosehorn National Wildlife Refuge. Kingfishers breed in Maine but winter farther south.

chapter five

WINGED VISITORS

One useful "camera hunting" method involves getting to a place before the wildlife does and hiding in a portable camouflage blind. Some species accept the presence of such a blind more readily than others. White-tailed deer, for instance, recognize anything new to their home turf as something foreign. Not so with many birds. Those which frequent tidal marshes, where new and often large chunks of driftwood appear with each tide, are especially accepting of a portable blind.

The day the kingfisher sat on my head clearly proves that. I was hoping to photograph black ducks—generally as wary a species as you'll find in Maine—and had trudged out across the Goosefare Marsh in Saco one predawn with camera gear and a camouflage-cloth blind in my backpack.

The open marsh above Goosefare Brook's east bank, where it meets Branch Brook, seemed to offer a good place to set up. While locating partway down the sloping embankment might have permitted me to

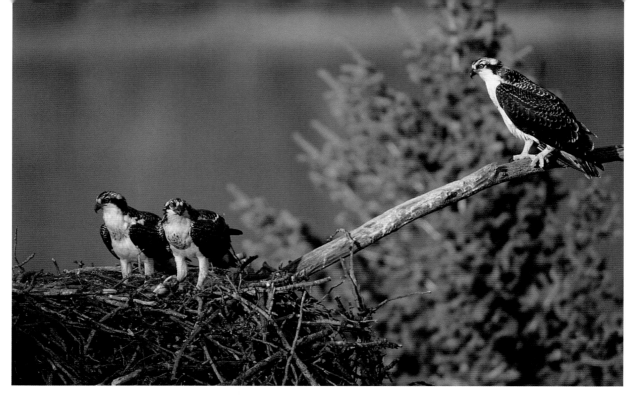

Thanks to conservation efforts and the restriction of pesticides, osprey have made a remarkable comeback. The species is no longer listed federally or by the state as endangered.

blend in better, that was out of the question; the slippery mud from the recently receded tide would sooner or later send me on a slick slide into the water.

No, it was far safer to set up atop the bank, in the open marsh. Ducks paddling down either of the two brooks toward the ocean would likely not scrutinize a blind there anyway, as the low angle of the early-morning sun would shine in their eyes. And even if they did see the blind, they would probably accept it as some new flotsam.

Camouflage cloth doesn't allow much visibility except through the eyepiece of the camera, and I had the lens trained on the confluence of the two brooks. So whatever flopped itself down on my head did so without my seeing it.

Only as it flitted off a few moments later did the kingfisher reveal its identity. Perhaps it left because of some slight motion I'd made?

That proved to be an incorrect assumption. The little blue-gray and white bird landed again in a moment. And this time it sat on my head for a good minute while it cracked the bones or shell of what-ever hapless fish or crab it had found and used this newly washed-up "snag" to scan the estuary. The kingfisher had left its perch overlooking the brook the first time because it had accomplished exactly what it wanted—it had spied something to eat. And it came back because the "snag" was a good place to sit and have breakfast.

What a grand sight we must have made!

THE BIRDS FROM AWAY

Many species of birds live in Maine for only part of the year. Some, like the belted kingfisher, nest here and leave only when the waters that they work for food freeze over, forcing them to seek warmer climes until spring.

Other species pass through briefly while on migration from far northern locales, where they nest for a short summer season, to the places where they spend the winter. Semipalmated sandpipers, for example, breed in the open tundra and in coastal environments across Canada and Alaska, then winter in the southern Atlantic states, along the Gulf Coast, in the West Indies, along the east coast of Mexico, and as far south

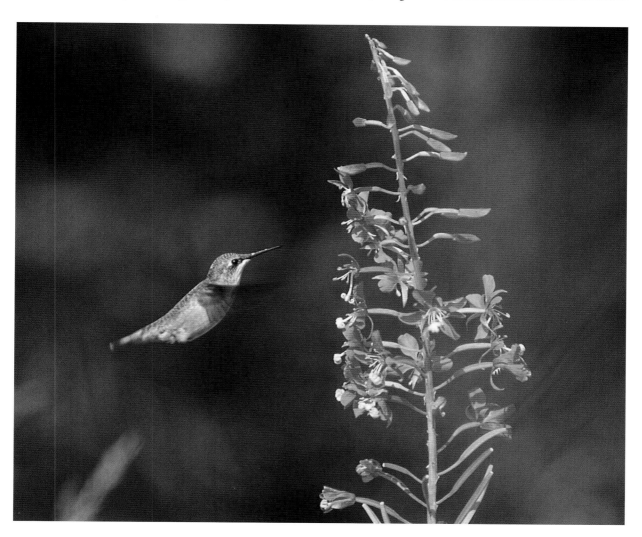

A female ruby-throated hummingbird checks out a stalk of fireweed. In September these welcome summer residents take flight for their wintering grounds in Central America.

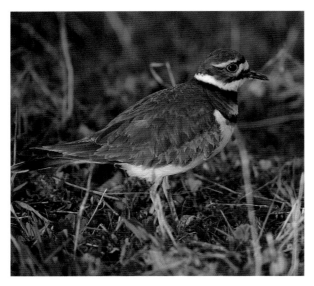

The Killdeer (above) is a ground nester. Its loud, distinctive call inspired both the common and Latin name (Charadrius vociferous) of this species. This individual was photographed at Moosehorn National Wildlife Refuge.

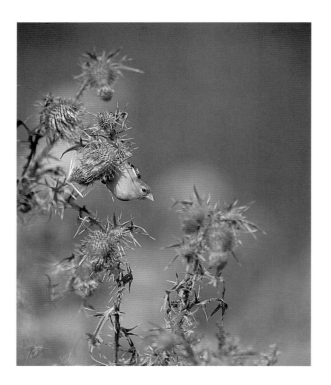

Maine's overgrown fields provide habitat for the thistle-loving American Goldfinch, which nests not in spring but in summer, when its favorite seeds become available.

as Chile. Hundreds of thousands of these little birds come through Maine in late spring and mid- to late summer, but are seldom seen otherwise.

Many other birds—including warblers, plovers, finches, bluebirds, and more—migrate to Maine's beaches or woods or backyards to nest and raise their young. Year-round Mainers welcome these birds, often the harbingers of spring, much as we do our human friends who live most of the year in other states and come to Maine in summer. Birds "from away" help to make wild Maine a wonderfully diverse place.

Because space does not permit listing or illustrating all of the hundreds of bird species that spend at least part of the year in Maine, I've focused on a handful of the most glamorous species in this book. Those interested in learning more about the many others should consult a good bird guide. Writing in *A Birder's Guide to Maine* (Down East Books, 1996), expert birders Elizabeth and Jan Pierson and Peter Vickery report that more than 400 species of birds have been recorded in Maine, including 330 that generally occur annually.

At least 130 of the 214 species that nest in Maine do not winter here. In short, most birds that nest here might be considered "from away." That's because despite its wide diversity of habitat suitable for nesting during warmer months, Maine has historically also offered a harsh winter climate.

But who knows? Some birds, such as the cardinal,

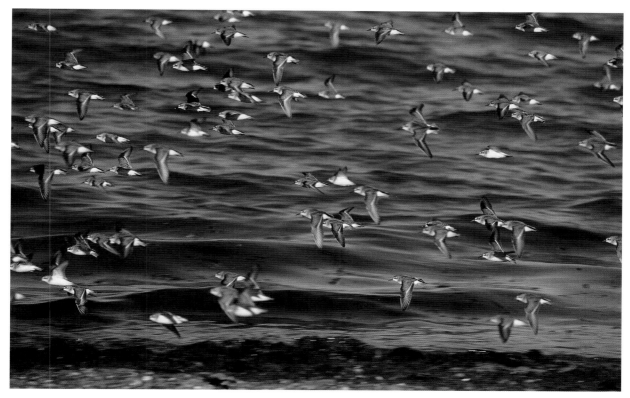

Semipalmated sandpipers at Lubec. These active birds can be seen in Maine from mid-April through October.

have taken to staying so long that they have become year-round residents in parts of southern Maine. Is that because Maine's winters have recently grown milder? Or are some of these birds getting tough enough to stick it out with the rest of us?

———————

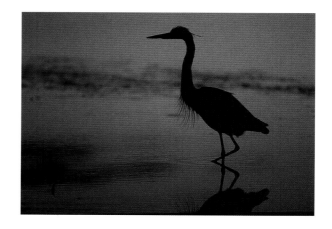

Great blue herons require tall trees for their nests and will fly up to eighteen miles from nesting sites to their feeding areas.

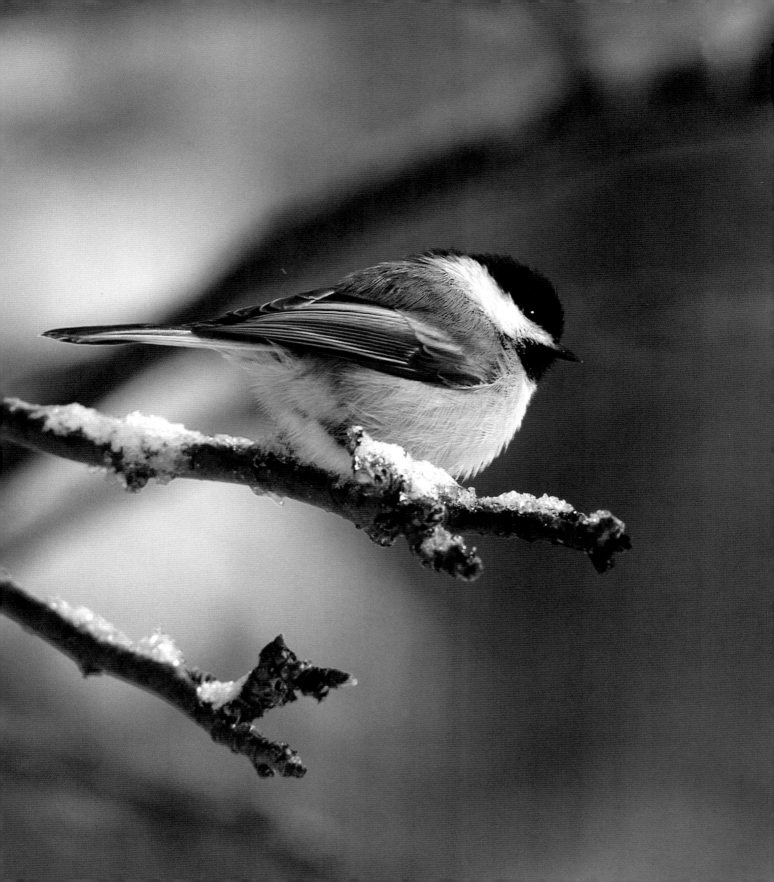

chapter six

THE
STATE BIRD

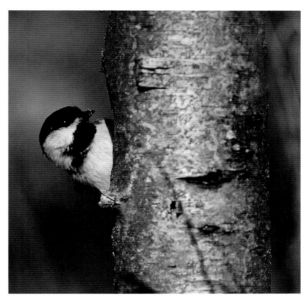

For their nests, chickadees excavate or enlarge existing holes in rotting wood, carefully carrying away all the telltale chips.

Splaaatt! Something hit the window hard.

The day was bright and sunny, but very cold. I looked out the big picture window onto the deck and confirmed that a bird had flown headfirst into its reflective glare, despite the hanging ornaments intended to warn birds away.

The chickadee lay motionless on the wooden deck. It was on its back, feet pointed toward the sky. That didn't look good.

Some birds either go into shock or knock themselves out when they hit a window hard like that, but snap back after a few minutes. This one seemed to be all right except for being unconscious. After checking the little bird for signs of bleeding or a broken neck, I decided to try reviving it. Perhaps the little guy would come to, given the chance.

To leave it on the deck unprotected, vulnerable to the chilly air of that November day—not to mention the neighborhood's occasionally marauding cat—seemed unfair. I placed the chickadee in an open shoe box and covered it with a heavy face cloth, leaving only its tiny head exposed. Setting the shoe box in the direct warmth of the sun, I sat back to wait.

It didn't take long. The little bird blinked its eyes and stared up at me. It didn't appear to be afraid.

Probably it was still stunned. I gently stroked the chickadee through the face cloth, warming it more. The bird wiggled, and after a few moments I removed the cloth.

Just before it flew off, the little chickadee looked me right in the eye. I can only speculate as to what it might have been thinking. But I'd like to believe the bird learned that its innate trust of humans was well founded.

THE CHICKADEES OF MAINE

Maine actually enjoys two species of chickadees: the black-capped chickadee that is our state bird, and the less frequently seen boreal chickadee, which is similar but has a brown head.

The black-capped chickadee is a definite favorite

In winter, chickadees roam in small flocks, searching bark crannies for cocoons, spider eggs, and dormant insects.

among those who enjoy birds, probably because it appears to be so fearless. Chickadees befriend us in the suburbs or in the deepest woods. They fly down from the treetops to visit with us. And they include among their calls a lovely song that proclaims their name: *Chick–a–dee–dee–dee.*

Some documentation exists confirming that chickadees are highly intelligent for their size. One bird bander reported to Smithsonian Museum ornithologist Arthur Cleveland Bent during the 1940s:

> Among the dozen or more species commonly taken for banding in my government-type sparrow trap, the black-capped chickadee was the only species with instinctive intelligence to remember its way out. This trap, with its entrance under inward-sloping wires, was successful through the failure of most birds to remember just how and where they came in and the confusion that resulted when escape was found impossible in any general direction, particularly upward. The chickadee, selecting a sunflower seed from among the mixed bait in the trap, went in, not to eat the seed there, but to get it out to where it could be opened on a branch. The little bird at its first visit would walk around the trap until the low entrance was discovered, then dart in, select a seed, and, if nothing disturbed it, head back whence it came and with little investigation find its way out. They rarely became confused as did the juncos, tree sparrows, and purple finches. After the first trip in and out, the same individual would fly directly to the entrance and as directly out again after he had grabbed the seed. If I shifted the position of the trap on the same spot, or moved it to a new location, the trail was learned after one trial.

The little birds that dive and fly in such a crooked pattern also stick it out with the year-round residents and help make the Maine winter go by with a few more smiles. As Arthur Cleveland Bent wrote in his 1947 classic, *Life Histories of Familiar North American Birds:*

> When we watch a flock of them in winter they remind us of a group of happy, innocent little children playing in the snow. Thinking back to the early days of New England's history, we can imagine that the Pilgrim Fathers, when the chickadees came about the settlement at Plymouth in 1620, watched them as we do now. They were, perhaps, the first friends to welcome the travelers to the New World.

Maybe that's why this tiny creature won out over a couple of hundred others to be chosen as Maine's state bird.

———————

Right-side up or upside-down or any position in between— it seems to make no difference to the ever-active chickadee.

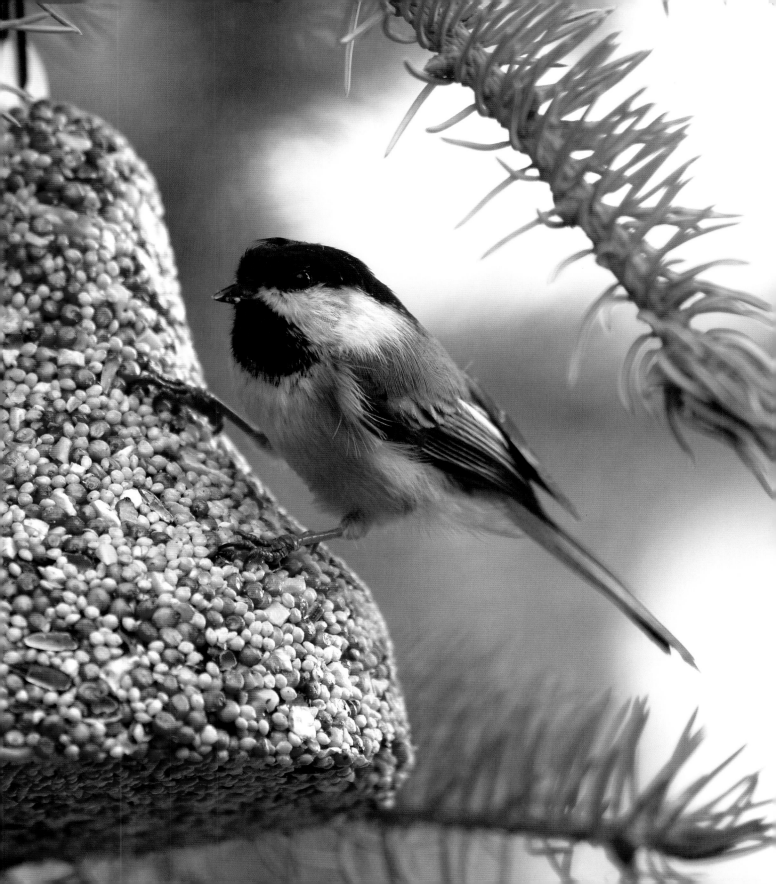

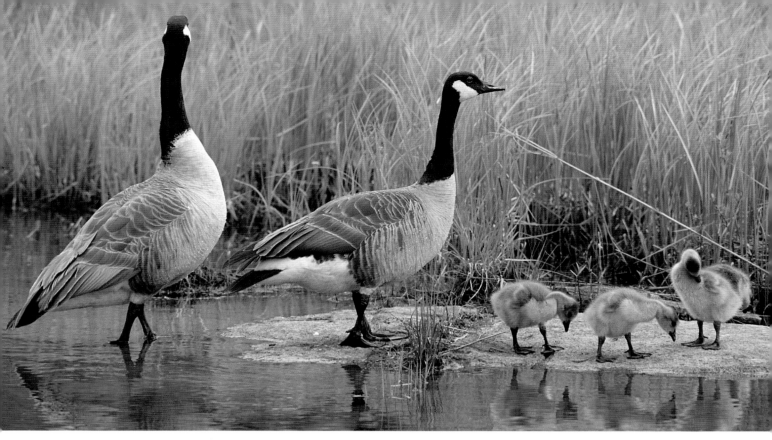

This pair of Canada geese at Moosehorn National Wildlife Refuge were not about to let the presence of a photographer prevent them from keeping the whole family together.

chapter seven

WATERFOWL

The two adult Canada geese watched warily as the pickup truck approached the grassy dike of the Mullen Meadow flowage at the Moosehorn National Wildlife Refuge, in Baring. The refuge flowages provide important habitat for breeding and migrating waterfowl, shorebirds, and wading birds, and a visit to one of them during spring elicits a vociferous response from the seasonally resident Canada geese. From late April into June each year, at least one pair of constantly alert Canada geese

lives at every flowage. It is virtually impossible to pass through without arousing them.

These two were no exception. Both honked loudly as they padded to the water on large webbed feet. Their little yellow offspring scurried to keep up.

The brood headed for the water, the adults still honking loudly. But suddenly they all stopped at the edge of the pond. The little ones huddled between their parents. The adults turned toward the grassy dike and took a few hesitant steps back up.

Why had they stopped and turned?

Then I spotted the lone gosling. It stood far up the bank of the dike, still in the tall grass. It flailed its little someday wings and called to its parents: *Wait for me—don't leave me!*

The two adults glared at the parked truck, the perceived threat. Were they looking for some indication of intent?

The little goose didn't move. It seemed to be afraid to cross the distance to the rest of the family. So the parents waddled back up the dike to collect the straggler, with the rest of the brood in tow. Then they turned and headed for the water again. Soon the whole family swam quietly along the far edge of the pond.

Why had the two adult geese risked their entire brood to rescue the lone gosling? If it were solely a matter of survival, the better strategy would seem to be to have sacrificed the one for the many.

And once they had turned back, why did they pause? Why hesitate? Could they have been thinking about the best way to deal with the situation? Perhaps weighing the odds? Do Canada geese feel about their offspring in any way as humans do?

Or is it all just instinct?

THE WATERFOWL OF MAINE

Early settlers in Maine found a rich diversity of geese and ducks. Common eiders nested on offshore islands and wintered in huge rafts along the coast; wood ducks nested in the dead trees on the shores of many lakes and ponds in every county of Maine; black ducks nested in the coastal marshes and wintered in the open inlets and bays as far north as Cobscook Bay. Many other species were also abundant.

Centuries of human development and exploitation of this resource changed all that, until by the early 1900s some of Maine's waterfowl species were in danger of becoming extinct. A few quotes from Maine ornithologist Ora S. Knight's self-published 1908 book, *Birds of Maine,* document the sad story for two of the species:

On the harlequin: "The days of this handsome little duck are fast passing and it is likely soon to be accorded a shelf along with certain other species formerly occurring along our coast."

On the American, or common, eider: "It is very probable that not more than twenty pair of these birds still remain along the entire eastern coast of Maine."

Federal migratory-bird protection acts and state game laws finally helped save many of our waterfowl species in the early part of the twentieth century. And in the years since, conservation-minded hunters in groups such as Ducks Unlimited and land-protection organizations such as The Nature Conservancy and the Maine Coast Heritage Trust have helped improve waterfowl habitat protection. Habitat has been set aside for conservation in national wildlife refuges, state wildlife-management areas, offshore islands, and important wetlands. Those efforts, along with careful

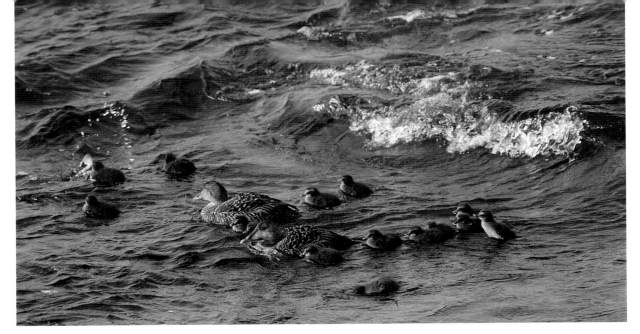

A brood of common eider ducks in the surf at Petit Manan National Wildlife Refuge. Eiders stay year-round on the Maine coast, feeding on mussels and other shellfish, which they swallow whole.

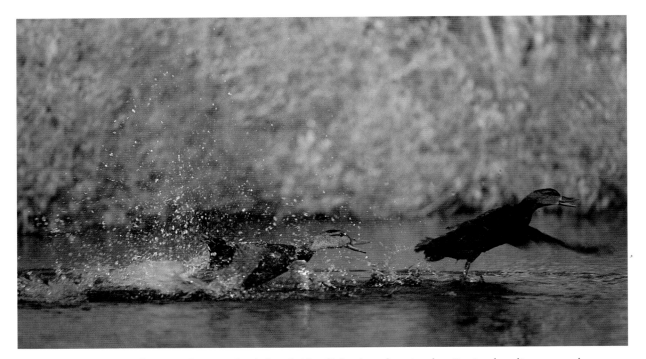

Black ducks winter on the coast, favoring the sheltered side of islands and peninsulas. During breeding season they generally nest in or near freshwater wetlands. This group was photographed at the Rachel Carson National Wildlife Refuge in southern Maine.

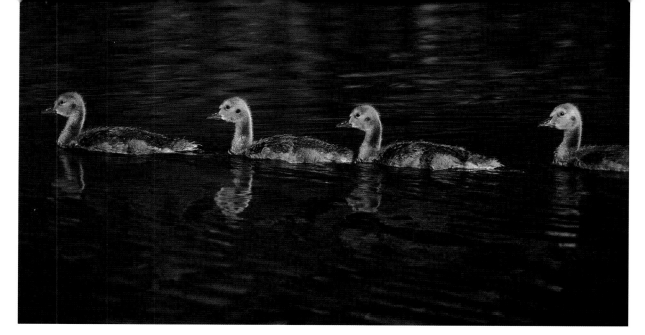

Thanks to efforts by the Maine Department of Inland Fisheries and Wildlife and the U.S. Fish and Wildlife Service, Maine now has a breeding population of Canada geese, including the birds at Moosehorn National Wildlife Refuge.

A brood of Common goldeneye ducklings takes a break. Goldeneyes are diving ducks, feeding on mollusks, insect larvae, and seeds.

management, have brought back and maintained a number of waterfowl species, including the harlequin and the eider.

Current estimates of Maine waterfowl numbers indicate healthy populations of Canada geese and many duck species. Some waterfowl nest here; others come to Maine for the winter. The Maine Department of Inland Fisheries and Wildlife reports that thirty-four species of waterfowl "migrate through Maine": eleven dabbling ducks, thirteen diving ducks, six sea ducks, and four goose species.

A recent midwinter survey counted more than thirty-three hundred geese and nearly a hundred thousand ducks in Maine. But those birds are just a part of Maine's total waterfowl population. Because many species migrate out of state during winter, the numbers that reside in Maine for part of each year are much greater. The U.S. Fish and Wildlife Service 2001 winter survey of waterfowl along the entire Atlantic Flyway—from Maine to Florida—counted forty million birds along this important flight path connecting vital habitats used every year by migrating waterfowl.

Some of those millions of birds wind up here for at least a part of each year, and they help to keep Maine wild.

———————

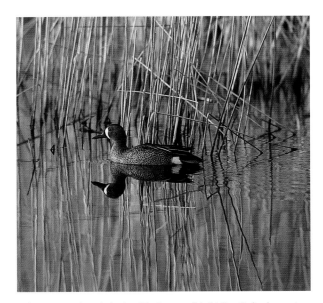

Blue-winged teal drake. Teal are a "dabbling" duck species, feeding at or near the water's surface and occasionally on land. They are more common in the Midwest than in Maine.

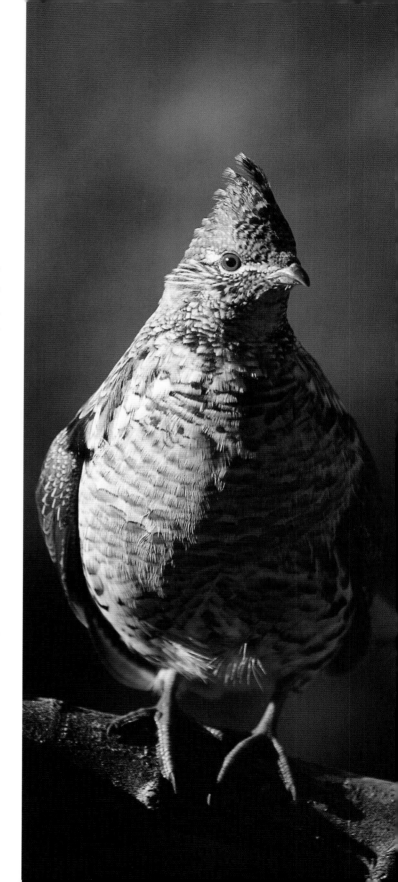

chapter eight

UPLAND GAME BIRDS

Tales about people and wild animals befriending each other make great bedtime stories. But are these stories ever based on fact? Some folks believe that such themes actually deceive children about the natural world. Anthropomorphism—the assignment of human emotions and responses to nonhumans, including inanimate objects, plants, and animals—is condemned by some as "Bambi-ism."

What would those folks say about Joe Suga's grouse?

An editor friend called about a rare opportunity to photograph a wild ruffed grouse that had grown attached to a maple sugar farmer in central Maine. That was an intriguing prospect; ruffed grouse rank among the wariest of the birds populating Maine. Unlike their cousins, the spruce grouse, they generally scurry off before you can draw a bead on them with a camera. Even the ruffed grouse living in the safety of game sanctuaries display behaviors similar to their kin in unprotected places. The ruffed grouse in the deepest woods of Baxter State Park are no exception. They, too, exhibit the behavior that earns the ruffed grouse the designation "heart-attack bird." Ever walk

Maine's mixed-wood forests provide
excellent habitat for ruffed grouse.

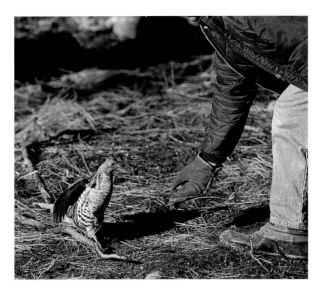

Joe Suga's grouse bonded only with Joe. All other humans were suspect.

through the woods enjoying peace and quiet, only to be startled by the flapping, flushing, and fleeing of a panicked ruffed grouse? Didn't it make your heart stop for a split second?

Still, stories come up now and then of individual ruffed grouse that seem to be tolerant of humans, or even attracted to people, and it sounded as if one of those unusual birds had discovered Joe Suga.

Following Joe through hardwood forest, we traveled down a gradual slope to his sugarbush. At the bottom of the hill, Joe stopped the all-terrain vehicle that he uses to work his sap buckets, and a ruffed grouse stepped onto the crude dirt road. After carefully eyeing the two strangers accompanying its friend, the bird ran over and greeted Joe.

For the next half hour the behavior of that grouse truly amazed us, as it willingly posed beside Joe Suga for a number of photographs. All I had to do was to catch it in a patch of light, out of the shade of the trees that blocked the early morning sun.

This behavior was so atypical as to make us wonder: What could this bird be thinking? Joe speculated that the puttering sound he made as he slowed his ATV was what had first attracted the grouse. Later, after it connected the sound with him—and since he did it no harm—it learned to trust this human.

Whatever the reason, the grouse felt totally comfortable with Joe. It definitely was a "one-man bird," however; as soon as Joe walked away, it lunged at my feet, flapping its wings against my legs while pecking at my boots!

THE UPLAND GAME BIRDS OF MAINE

Ornithologists break out a number of bird species as upland game birds. These ground dwellers feed on acorns, plants, and insects. Many travel in flocks. More than twenty species classified as upland game birds exist in North America today. All of these birds can fly, and many typically take off just as explosively as their cousin the ruffed grouse—an effective survival tactic to startle any would-be predators that come too close.

Early European settlers found three native upland game bird species in Maine: the ruffed grouse, the spruce grouse, and the wild turkey. They also found the woodcock, which had long ago evolved into more of an upland species although it is still classified by ornithologists as a shorebird. Later settlers introduced the ring-necked pheasant, imported from Eurasia.

The ruffed grouse—known in Maine as the

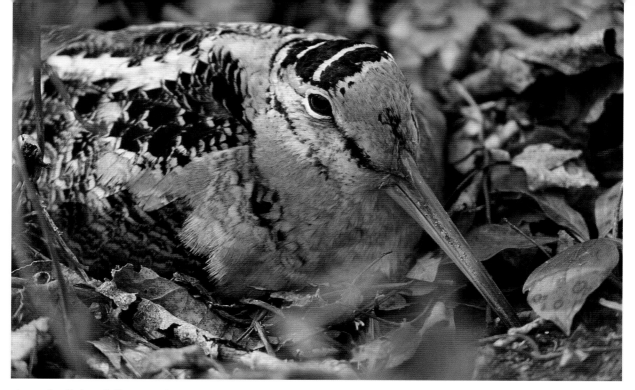

A woodcock's long bill is specialized for feeding on earthworms, and its high-set eyes allow for 360-degree vision. Woodcock populations in the United States have shown a gradual decline in the past thirty years, probably due to reduction of their preferred habitat—young second-growth hardwood stands.

"partridge"—was probably the most plentiful game bird species here three centuries ago, and it still is today. Native Americans and early settlers alike enjoyed the ruffed grouse as a staple of their wild food supply. Annual harvests in modern times still number more than half a million birds in Maine.

Wild turkeys historically lived along warmer coastal zones, with the greatest numbers found in what today are York, Cumberland, and Oxford Counties. But even as far back as 1672, English adventurer John Josselyn wrote of the turkey: "I have also seen threescore broods of young Turkies on the side of a Marsh, sunning themselves in a morning betimes, but this was thirty years since, the English

and the Indians having now destroyed the breed, so that 'tis very rare to meet with a wild Turkie in the Woods."

By the early 1800s the clearing of habitat for farms and the uncontrolled exploitation of the wild turkey led to its complete extirpation in Maine.

That changed after the Maine Department of Inland Fisheries and Wildlife made several attempts to reintroduce this popular game species. Finally, the release of a handful of wild turkeys trapped in Vermont in the 1970s led to a healthy enough population in Maine that hunting enthusiasts have enjoyed carefully controlled open seasons since 1986.

The reversion of much old farmland back to

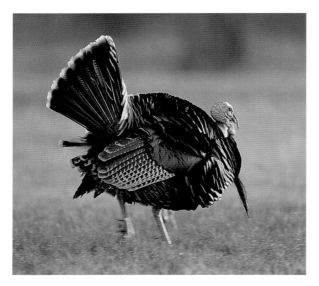

Wild turkeys breed during April and May in Maine. The toms compete vigorously for breeding rights, using both visual and vocal displays.

woodland habitat has benefited these reintroduced birds. Today thousands of wild turkeys roam Maine's wild places, farmland edges, and even some suburbs!

As a popular game species, the woodcock has probably existed in substantial numbers in Maine for centuries. Woodcock populations have been carefully managed for decades, including at the Moosehorn National Wildlife Refuge near Calais, which the U.S. Fish and Wildlife Service established specifically for this species in the 1930s.

The spruce grouse may be the most unsuspicious of all the larger birds found in Maine. Its trusting behavior long ago earned it the nickname "fool hen." Perhaps because of its trusting nature, its numbers have been significantly depleted, and in Maine it has

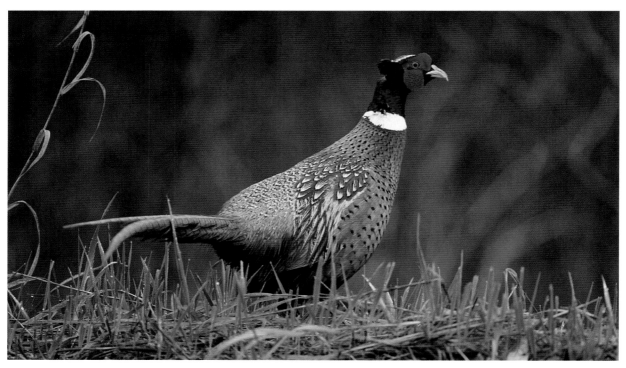

The ring-necked pheasant is an introduced species that has adapted readily to a wide range of North American habitats, including Maine's forests and clearings.

been protected from hunting for a number of years. This rarely seen game bird generally inhabits dense spruce, fir, and cedar forests.

One of my own most charming moments with a wild animal came when I was photographing a spruce grouse that was trying to enjoy a dust bath in a patch of open dirt. I say "trying to enjoy" because a large stick was intruding into the space enough to poke the bird in the side as it attempted to roll in all that lovely dirt. The stick not only bothered the grouse, it also ruined the photo opportunity. The bird, perhaps already relaxed from several minutes of my proximity, calmly watched as I tugged the annoying stick out of the way.

Glimpses of such trusting behavior from a truly wild animal like that spruce grouse or Joe Suga's ruffed grouse make me wonder what wildlife behaviors greeted the humans who first wandered into the woods and marshes of wild Maine.

———————

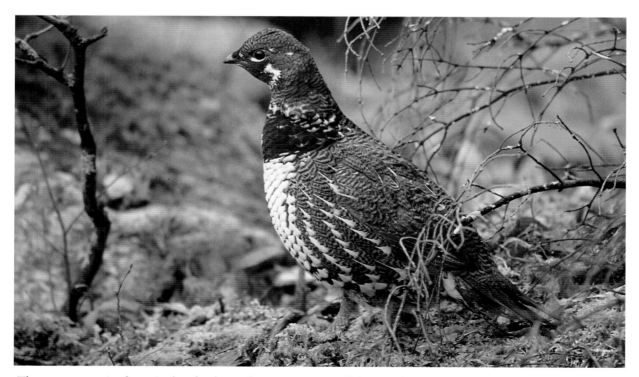

The spruce grouse is often mistaken for the much more common ruffed grouse, but it lacks the ruffed grouse's broad black band across the tail and the tufted feathers atop the head.

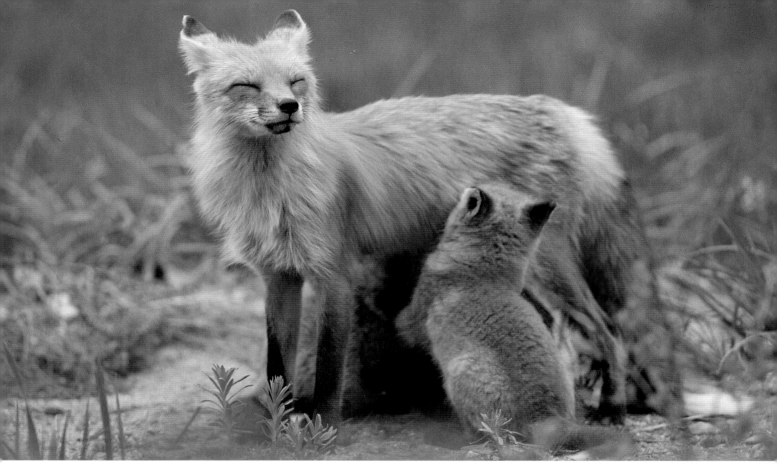

Fox kits are born in March or April and don't leave the den until they are four to five weeks old. They are weaned in their eighth or ninth week.

IN THE PRESENCE OF FOXES

The vixen loped up the Charlotte Road, which fronted the abandoned gravel pit where her five hungry kits waited in the den. Once again she carried no food.

It seemed that she was going to pass by the den to continue her morning hunt when she suddenly stopped to sniff the ground. After only a moment's pause, she bounded off the road to follow the scent trail left several hours earlier. She didn't call to her kits as she scooted up the hill, but instead ran to where the roadkill snowshoe hare lay waiting to be recycled.

It was a peace offering—a way to show that I

meant no harm to her family. I'd worked with this den for several days from behind a tripod-mounted telephoto lens, at a respectful distance of several hundred feet. To get more effective photographs would require getting closer, but a red fox will relocate her kits if she feels that her den has been compromised. Perhaps the gift would tell her that this photographer was friend, not foe.

A principle of responsible wildlife-watching or photography says that you shouldn't interfere with the lives of wild subjects. Some might condemn my providing food to these foxes, feeling that it could help them lose their fear of humans—could "take the wild out of wildlife." But what is natural behavior in any wild animal? The journals of early explorers and settlers in North America suggest that many animals were not naturally afraid of humans. It could be argued that the fear of humans is a learned behavior that developed after years of harassment and exploitation.

This vixen had five youngsters to feed, and she was doing it by herself; her mate hadn't shown up even once in three days from dawn to dusk. The toll showed clearly on her gaunt body. Should I simply watch as her family drew ever closer to disaster because of her inability to find enough food on her own?

I can only guess at what had happened to the dog fox. The den's proximity to the paved road may have meant that the male became roadkill himself. While this might all seem to be rationalization, the likelihood was that we humans had already interfered with these foxes, so I felt justified in bringing them the hare.

The red fox mother nosed over the dead hare and then looked right at me. I held my breath. Her face seemed to work through a series of expressions, from concern to a flicker of suspicion to a hint of—what *was* that look?

Attributing thought and emotion to wild animals also invites criticism. But I'll never doubt that this fox was grateful for the help. It showed clearly on her face. It was as if she were thinking, *Maybe this one's not such a bad guy after all.*

It was at this moment that she decided to trust me with her youngsters. That was lucky for her. It encouraged my continued help in feeding her hungry kits, and I scoured the highway for roadkills en route to the den each day. Her family enjoyed a considerable amount of food during the next weeks as a result.

It was also lucky for me. After that morning, she permitted much closer access to the den—and provided the ultimate reward several days later when she called two of her pups out to nurse not thirty feet away.

I had been accepted in the presence of foxes.

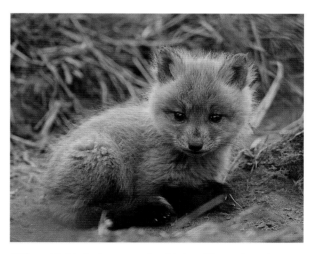

When this kit is three months old, it will start learning to hunt. Foxes enjoy a varied diet, including mice and voles, squirrels, woodchucks, ground-nesting birds and eggs, berries and other fruits, insects, and even corn.

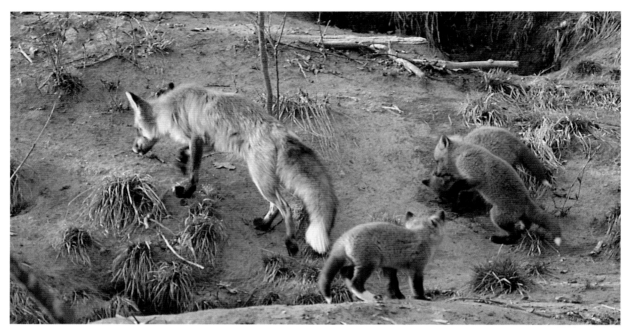

The female handles all the responsibility of preparing a den. She will often take over a woodchuck or porcupine burrow but may also dig her own in a suitable sandy bank.

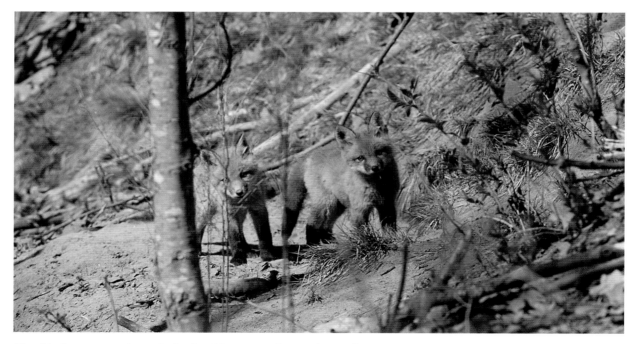

Two kits have ventured outside the den. The average litter is four or five.

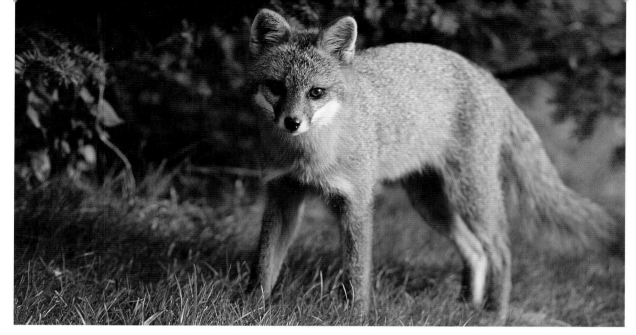

Foxes, especially the tree-climbing gray fox, are the most catlike of the wild canids. Though relatively rare in Maine, grays are more abundant to our south and west, and can out-compete red foxes in the same habitat.

THE FOXES OF MAINE

The red fox has thrived in Maine since being introduced to North America by early European settlers. (Some researchers believe that a subspecies of red fox already inhabited this continent and that the native and introduced populations then interbred.) The gray fox, originally a southern species, has expanded its range into Maine more recently, and the state today enjoys healthy populations of both species. The red fox's range covers the entire state, while the gray fox is found mostly in southern Maine.

Red foxes appear to be larger than gray foxes, probably because the gray fox is stocky, with shorter legs. The gray actually is a bit smaller on average, but adults of both species typically range between eight and twelve pounds.

Both species live in brushy and wooded areas, but the red fox seems to avoid the more heavily forested lands that the gray fox seems to enjoy—perhaps because the gray fox can climb trees. The gray is also the shyer of the two species, and with its proclivity for living in dense cover is seldom seen. Both species tend to be nocturnal in areas where they feel threatened during daylight hours.

Because foxes are opportunists in their diet, they can survive in a variety of habitats. This adaptable behavior allows them to do quite well living on the edge of suburban areas. While they may not be aware of it, many folks in residential areas of Maine share their neighborhoods with these most delightful of wild creatures.

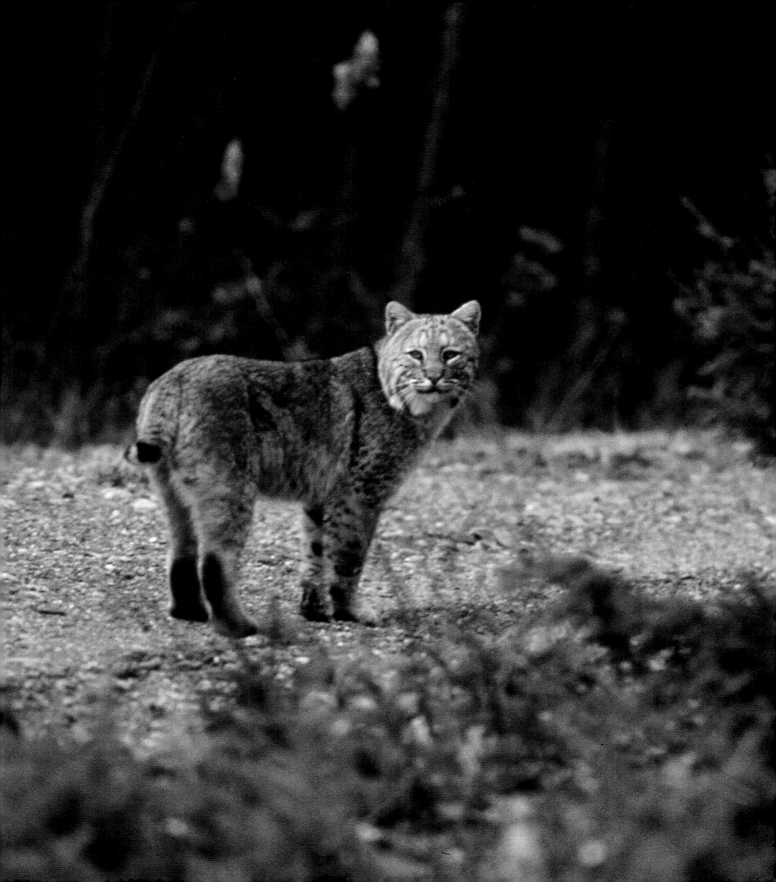

chapter ten
WILD CATS

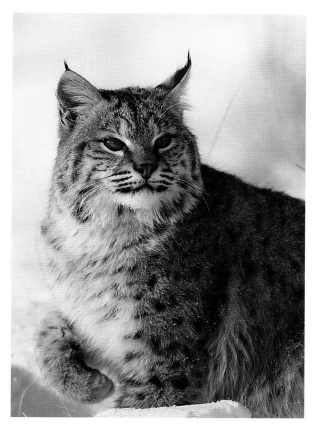

Bobcats, especially the younger animals, often have spots on the front legs and bellies.

How many bobcats have you seen in the wild in the Maine woods? Did they hang around to pose? How long do you suppose the bobcat on the facing page stared at the car as the sun set over the Baring Division of the Moosehorn National Wildlife Refuge, near Calais?

There was no time to check a watch. But trust that, as it so often does for a wildlife photographer, the whole day came down to a matter of seconds just then.

There was no time to set up a tripod for a heavy telephoto lens. To hold the camera steady, all I could do was open the car door a bit to get the angle for the shot and rest the camera on the open window.

Shooting through the windshield was definitely out; the curvature of the glass makes for poor optical quality. While you *can* shoot through flat glass that's within the minimum focusing range of a telephoto lens, curved glass distorts an image badly. And dirty curved glass is even worse.

I eased the door open as quickly and as smoothly as possible, without abrupt motion. The bobcat just stared at me. Oh, it saw the door move all right. But it also seemed curious about the big glass eyeball that now stared back at it.

Sliding behind the door, I crouched, cranked the shutter speed up to $\frac{1}{125}$ second, and made this photograph. The next frame, shot a split second later, shows only half a bobcat—the east end headed west!

Spotting a truly wild cat in Maine, let alone photographing it, is a rare event. That's why photographers sometimes employ representative models—captive animals in a zoo or from a special wildlife facility—to show what these most elusive of wild animals look like. And I have no problem with using a handful of images of these accessible individuals if it

This bobcat's curiosity held it still just long enough for it to be photographed. Although bobcats are fairly widely distributed across the United States, they are seldom seen.

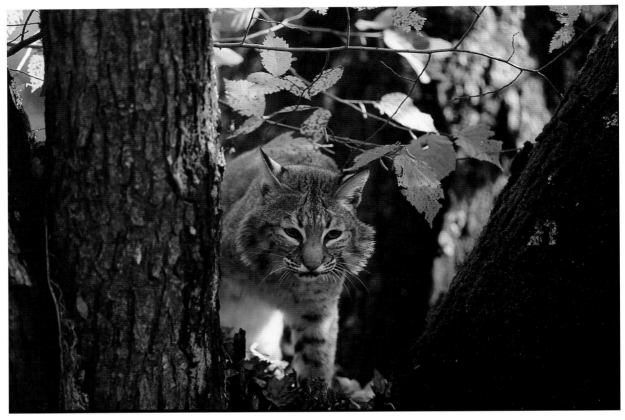

Bobcats primarily hunt on land, but have been known to wade and swim and may even prey on beavers.

can help folks appreciate these seldom encountered residents of wild Maine.

But perhaps we do encounter, or almost encounter, wild cats more often than we know. Do you think it could be a passing bobcat that wakes us when we hear something go bump in the night?

THE WILD CATS OF MAINE

While the bobcat described above was photographed in the northern part of Washington County, the species did not originally live that far north.

America's first great naturalist, Ernest Thompson Seton, described the historical range of the bobcat as "throughout the transition or southern temperate zone of North America, from sea to sea." A map he drew in 1920 shows this range stopping south of Maine, halfway into New Hampshire and Vermont. Seton traced the "recent extension" of the bobcat's range with a dotted line extending into central Maine.

The Canada lynx, on the other hand, once lived throughout the forested region that today includes Maine, across most of Canada and Alaska, and in

portions of a few other northern-tier states. According to Seton, these animals prefer the "primitive woods, the unbroken forest."

Strangely, these two elusive animals have in a sense traded places. Following settlement of this region, bobcats expanded their range throughout the entire state of Maine. And while no one knows how many ever did live here, the Canada lynx is now so rare that few people, including those who have worked in the woods all their lives, have ever seen one in the wild. That's why the active lynx den sites recently discovered in the forestlands of the St. John River watershed made headlines. Fortunately they are on land protected by the Maine Chapter of The Nature Conservancy.

Maine is one of just five states, and the only eastern one, where the lynx currently ranges. Partly because of this, the U.S. Fish and Wildlife Service listed it on April 21, 2000, as threatened in the contiguous United States. Some researchers estimate the entire lynx population in the lower forty-eight states to be only two hundred animals.

If you consider this, it seems hard to believe that Maine used to have a year-round open hunting season on lynx and paid a bounty of fifteen dollars for each one eliminated. The Maine legislature only changed the laws to provide complete protection for the lynx in October 1967.

Lynx are strictly carnivores, and while they will feed on birds and small mammals, they primarily target the snowshoe hare. Since the snowshoe hare is such a major prey species, the periodic rise and fall of its population probably significantly impacts the lynx's prospects for long-term survival.

Research suggests that the bobcat enjoys a less specialized diet than the lynx. The bobcat thrives on a variety of small game, including snowshoe hare, muskrat, squirrel, porcupine, and beaver. It also feeds on an occasional white-tailed deer, and even on moose. As an animal that also tolerates closer proximity to humans, it may face a brighter future than its more mysterious cousin.

And what of that even larger wild cat, the mountain lion or eastern cougar? According to Seton and others, the cougar historically ranged all across North America but was pretty much wiped out—except in the western United States and Canada—by 1900.

In his 1925 book, *Lives of Game Animals,* Seton related a fascinating story by Charles H. Daisey, "the well known guide of Camp Phoenix on Sourdnahunk

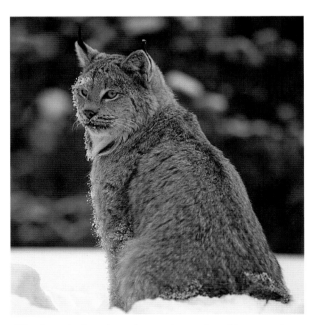

The Canada lynx is at the southern edge of its range in Maine. Lynx are longer-legged than bobcats and have larger paws, which are densely furred for easier walking on deep snow.

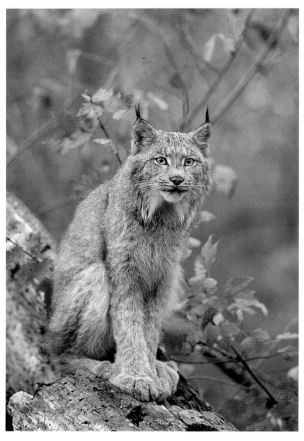

Lynx are solitary, nocturnal hunters and rely on stealth to ambush their prey. The photogenic lynx shown on these pages lives in captivity.

Lake" who encountered two "panthers" in the woods that today make up the western boundary of Baxter State Park. Daisey wounded one with a revolver, but it escaped. Nonetheless, its tracks convinced this experienced woodsman that the animals of his 1907 encounter were indeed cougars.

A trapper caught the last specimen to be recorded in Maine near Little St. John Lake, along the Quebec border, in 1938, and the U.S. Fish and Wildlife Service finally listed the eastern cougar as an endangered species in 1969.

A number of reported sightings in recent years have fueled a debate: Does the cougar still live in Maine today? While reliable witnesses have reported seeing them in different parts of the state—and even DNA evidence has been collected—as of this writing, the official position of the Maine Department of Inland Fisheries and Wildlife is: "There is no evidence that suggests that a breeding population of cougar exists in the Northeastern United States. The occasional sightings of cougar in Maine and other states are believed to be of captive cougar that have been released in the wild or have escaped from their owners." But the report adds: "Continued undocumented reports of sightings and sign suggest that the Eastern Cougar be listed as a species of Special Concern in Maine."

Perhaps it's the cougar that sometimes goes bump in the night. . . .

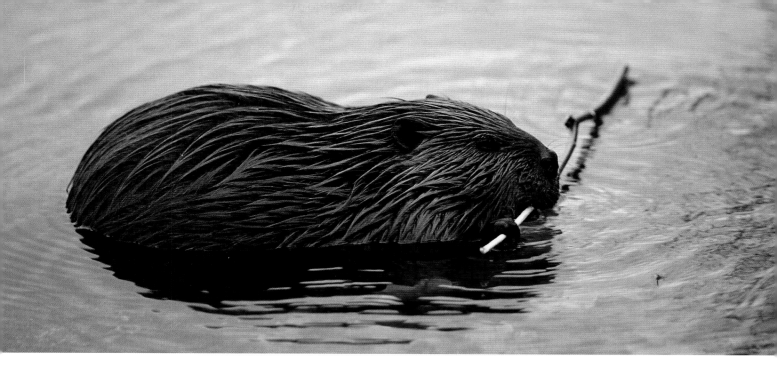

Beavers particularly favor the bark of hardwood trees but will also eat the buds and bark of softwoods in spring, as well as various water plants, cultivated crops, and even an occasional dead fish.

chapter eleven

OTHER FURBEARERS

The beaver swam back and forth along the shore of the pond as it gathered its winter food supply. Living up to its reputation for busyness, the animal made many trips past our cabin every morning, hauling the limbs it had cut from trees on the far northern shore. When it reacted its lodge on the south side of the pond, it dived under the surface and jammed each new branch into the mud on the bottom to add to its cache.

Each time it swam by, it made an inviting target

for my camera, except for one thing: This was a week of dull overcast skies, and the early morning light— dim enough even on a good day—never permitted a fast enough shutter speed to capture the critter on film.

Then, on the fifth morning of its daily tease, the beaver decided to stop and have a snack on the shore right in front of the cabin, offering the first opportunity for me to get an image of an animal that has such a nocturnal reputation.

What made the beaver decide to stop and munch

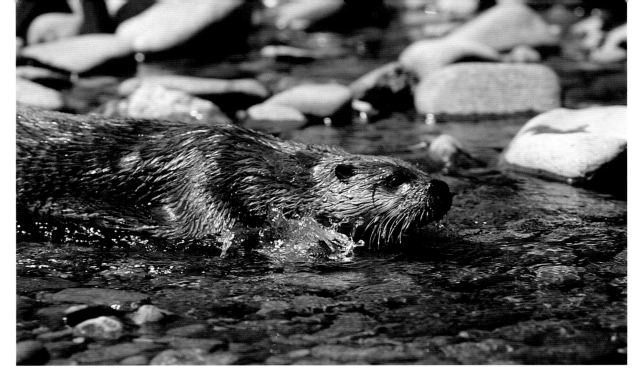

Active, intelligent, and powerful, river otters range over large territories. In Maine today, they are listed as common but not abundant. This is a captive individual.

the bark from its alder stick right in front of me? And why was it not afraid to show itself to begin with, as most people believe would be the natural behavior of this—or any other—wild animal?

Only that beaver knows for sure.

THE FURBEARERS OF MAINE

The term *furbearer* generally refers to an animal whose pelt has commercial value. According to the Maine Department of Inland Fisheries and Wildlife, the furbearers of Maine legally sought for their pelts include coyote, red and gray fox, bobcat, fisher, mink, marten, raccoon, skunk, weasel, otter, beaver, muskrat, and opossum. Some of these species, such as the wild cats and the foxes, are celebrated in their own chapters in this book for their distinct characteristics.

The beaver has long been one of the most sought-

after furbearer. In fact, the pursuit of beaver fueled the exploration of North America and even resulted in wars, as early trappers and companies of fur traders sought out this most favored of North America's animal resources. As Edward W. Nelson, chief of the U.S. Biological Survey, wrote in his epic book, *Wild Animals of North America* (published by the National Geographic Society in 1918): "Their abundance and the high value of their fur exercised an unparalleled influence on the early exploration and development of North America. Beaver skins were the one ready product of the New World which the merchants of Europe were eager to purchase."

That popularity, and the use of the beaver pelt as a unit of exchange, eventually led to the decimation of these easily trapped animals. Naturalist Ernest Thompson Seton estimated that a primitive population of

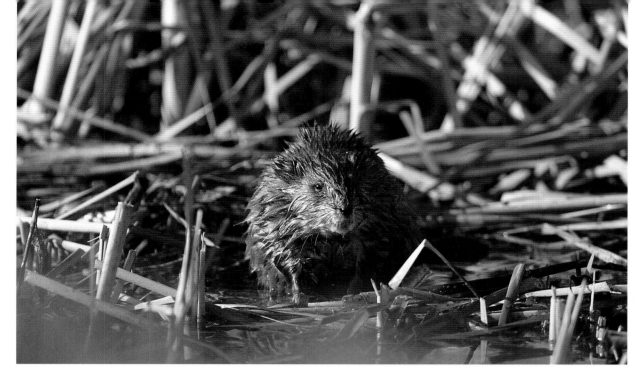

Muskrats in northern areas such as Maine weigh three to four pounds and measure about twenty-three inches long, tail included. They may raise two or three litters of young each year.

sixty million beavers existed across North America before the Europeans arrived. But by the dawn of the twentieth century, Seton wrote, "In practically all of the United States, the Beaver were killed off. A few small regions still held a remnant; among those were Maine, Minnesota, and the Rockies in Wyoming, Montana, and Idaho."

A knowledge of the need to conserve this and other wild animals awoke in the early 1900s (and continues to this day), which has led to more en-lightened management of beaver populations. Indeed, the beaver has recovered nationally, and in Maine today we enjoy a healthy enough population of these fun-to-watch animals that carefully regulated trapping is still permitted.

Some might ask: Why do we still want beavers? We now wear coats of Polartec™ and Thinsulate™.

And beavers sometimes do great harm to the works of both humans and nature by flooding roads and timberlands and by creating wetlands where it's inconvenient for us.

But beaver wetlands benefit many species that need such environments to survive. Beaver ponds serve as habitat for a wide range of species, from waterfowl to fish and amphibians. Even moose dine in them. Among the other animals that benefit from the good works of the industrious beaver are other furbearers that you might be lucky enough to see in the wild places of Maine: the muskrat, otter, and mink. In addition, the pine marten, weasel, and fisher occasionally prowl the state's waters and wetlands.

Many folks have never seen these animals in the wild. That's probably because they've all learned to evade humans—just as the beaver did. Ask most folks

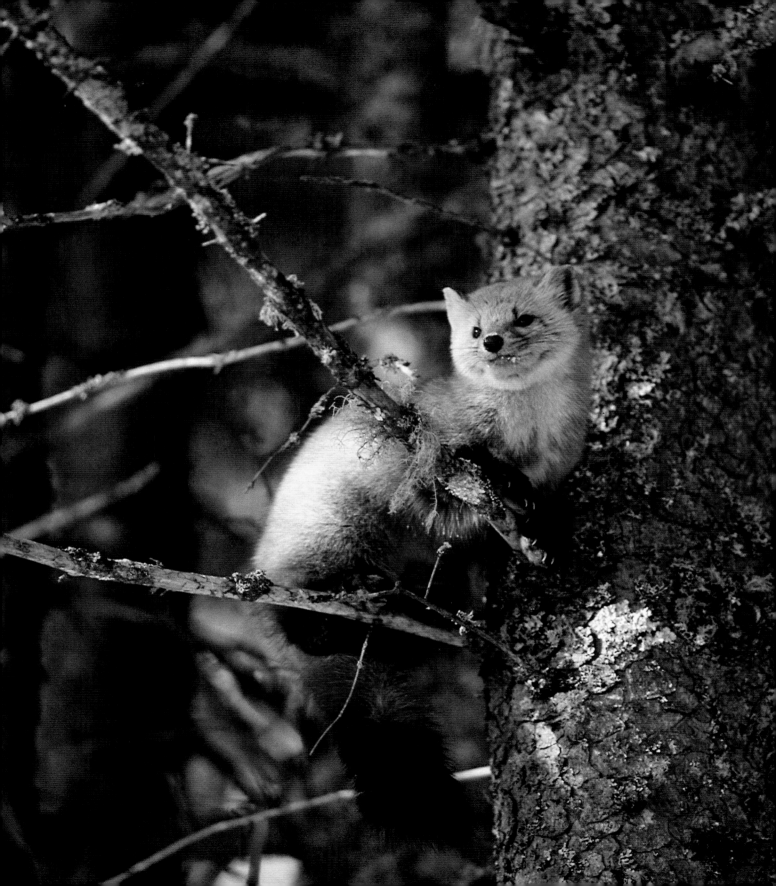

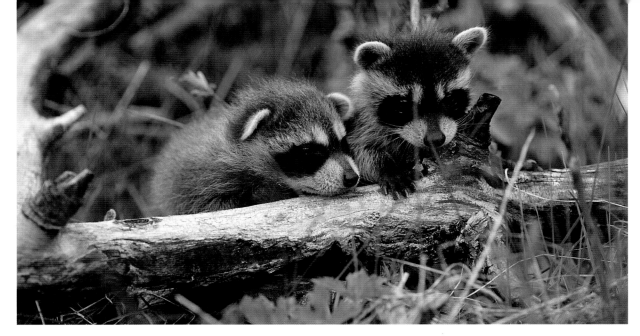

Raccoons are most abundant in the southern half of the state. They seem to thrive in proximity to humans, which raises concerns because they are also one of the Maine wildlife species most likely to be infected with rabies.

about beavers, and they'll tell you that they only come out at night. Collective human experience over the centuries says that beavers typically only show up as the sun's going down.

But what *is* the "natural behavior" of this intriguing animal? The trend toward nocturnal behavior probably evolved from the heavy persecution of this species by humans. Historical writings and the reports of careful observers at places where beavers today are protected from human disturbance suggest that they are just as likely to come out to do their chores during daylight hours—as did the one that posed for its portrait that morning at Baxter State Park, a place where you can still find a taste of what a wilder Maine must have been like.

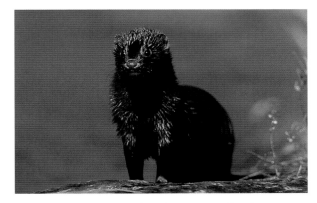

Mink hunt mostly at night. They are equally adept on land and in water, preying on hares, frogs, insects, birds, fish, snakes, and sometimes muskrats.

Martens are considered abundant in the northern half of Maine but scarce in the southernmost part of the state. This one was photographed at Daicey Pond in Baxter State Park.

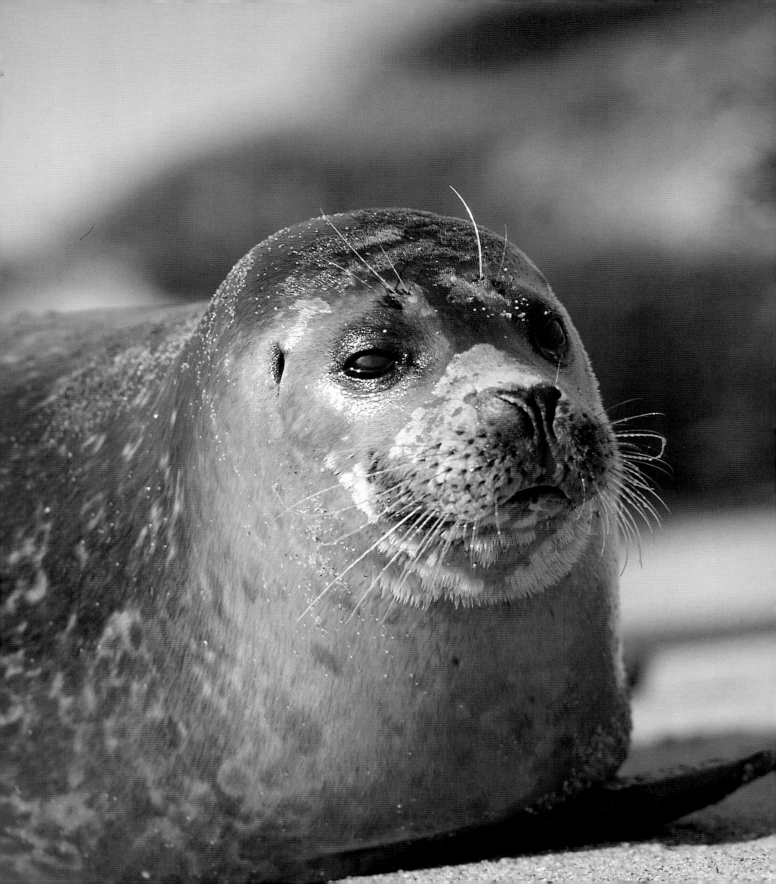

chapter twelve

SEA
MAMMALS

Harbor porpoises, small toothed whales, are the cetaceans seen closest to shore in Maine. Their population in the Gulf of Maine has increased dramatically thanks to conservation efforts and a decline in gillnetting, but the National Marine Fisheries Service still lists them as threatened.

While playing Frisbee one early summer morning on Bayview Beach, overlooking Saco Bay, our two rambunctious black Labrador retrievers caught the attention of a curious harbor seal.

It was low tide. The hard-packed sand just above the tideline made a good walking surface, and since the two dogs loved to jump into the breaking waves to catch their bright yellow toy as much as they enjoyed running down the hard sand to try to catch it on the fly, we played at the edge of the surf.

That's when the harbor seal spotted the dogs. As it swam just beyond the breaking waves, it stretched its neck and strained to see why they were jumping and frolicking in the surf.

The seal followed us along the beach for half a mile. Sometimes it came in closer for a better view. But Bosley and Yoda, distracted by the Frisbee, never saw it.

What might that seal have been thinking? Could the flying Frisbee have attracted the seal's attention even though it couldn't see its color?

Harbor seals are known for their playfulness.

Audubon bird researchers working one summer on Stratton Island, off the Scarborough coast in Saco Bay, talked about being joined by seals when they went swimming in the sheltered bay on the island's ocean-facing side, where the seals often haul out on the rocks. And André, the famous harbor seal who summered with Harry Goodridge and his family in Rockport for many years, was so friendly that he inspired both a best-selling book and a movie.

Harbor seals are the most commonly seen marine mammal in Maine waters. Their population has rebounded since 1972, when the Marine Mammal Protection Act went into effect.

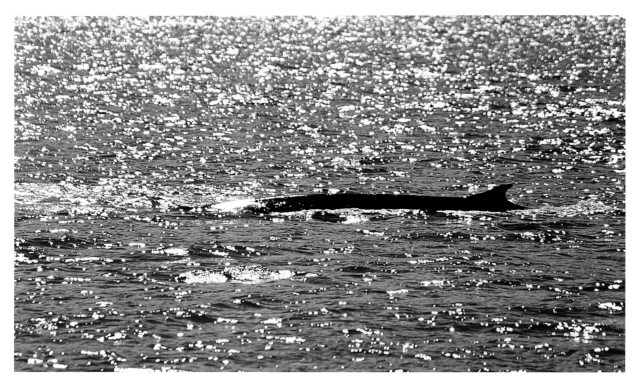

A finback whale is an extremely rare sighting in the Gulf of Maine, as these large (sixty- to eighty-five-foot) baleen whales generally avoid shallow coastal waters. Until the twentieth century, finbacks' great speed and maneuverability protected them from being overhunted, but today the species is listed as endangered.

The scientific name of the harbor seal, *Phoca vitulina,* loosely translates into "sea dog." Most taxonomists think that seals and dogs descended from the same ancient, long-extinct ancestor. Similarities do exist. The face and head of the harbor seal resemble those of several popular dog species. And strangely enough some seal species, including the harbor seal, are susceptible to viruses that infect dogs, especially distemper.

Like dogs, harbor seals have an excellent sense of smell. They also hear extremely well despite the fact that they do not have external ear flaps. Both canids and pinnipeds have excellent vision (mostly in black and white for the seal, though dogs enjoy limited color vision).

Perhaps the seal that watched my dogs that morning felt some distant kinship with those four-footed land animals. Or did it just want a turn at catching the Frisbee?

THE SEA MAMMALS OF MAINE

A number of seal, dolphin, porpoise, and whale species inhabit the waters off Maine's shoreline for at least a part of the year.

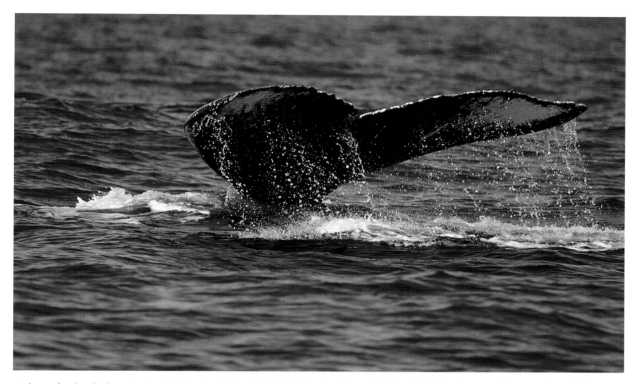

A humpback whale raises its distinctive flukes. Individual animals can be identified by the markings on their flukes. Humpbacks migrate to northern waters, including the Gulf of Maine, to feed in the summer and have been spotted as close as a half-mile from shore, according to the Marine Mammal Stranding Center.

Harbor and gray seals live along the coast year-round, and harp, hooded, and ringed seals occasionally visit in the winter months. Harbor porpoises, Atlantic white-sided dolphins, and white-beaked dolphins all frequent the waters of the greater Gulf of Maine, which stretches from Canada to Cape Cod.

Both baleen whales, which nourish their huge bodies by straining plankton through the "whalebone" of their mouths, and toothed whales, which eat fish, squid, occasional small mammals, and even birds, also live in the Gulf of Maine for at least part of the year.

Toothed whales found in these waters include the endangered sperm whale, the killer whale, and the pilot whale. The baleen whales that frequent the Gulf of Maine include the endangered blue whale, the endangered northern right whale, the endangered sei whale, the minke whale, the endangered humpback whale, and the endangered finback whale. Minkes and humpbacks are the most commonly seen species, as they spend summer months not far off the coast, ranging all the way from Eastport to Kittery.

Some readers might think the word *endangered* is overused in the preceding paragraph. But it's sadly true: Very few of these animals—the largest of the world's

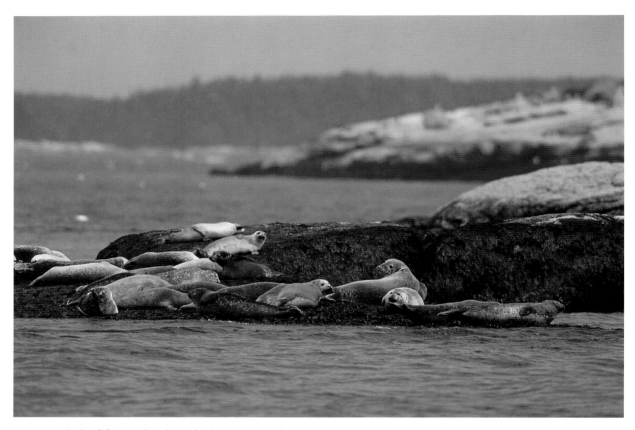

A gray seal (third from right) shares basking space with its smaller harbor seal cousins. Despite their name, gray seals are not always gray, and the best way to distinguish them from harbor seals is by their larger, more square-shaped head and arched muzzle.

mammals—exist today after centuries of overhunting. And while enlightened governments have in recent years protected most whales, other hazards, including entrapment in fishing gear and collisions with boats and ships, still take an annual toll. How best to maintain, let alone bring back, healthy populations of these magnificent animals fuels many debates among professional wildlife managers and those who earn their livelihood fishing these same seas.

The story of the harbor seal, probably the most familiar of Maine's marine mammals, provides a brighter picture. Recent aerial surveys counted at least thirty thousand of these seals hauled out on rocks along the Maine coast. Such numbers represent a dramatic increase in this species from not so many years ago. Hunted and persecuted as an animal that competed for the fisheries resource, harbor seals had a bounty on their heads in Maine until 1905, and in

Massachusetts until 1962. They still were hunted—nearly to extirpation—until finally protected under the Marine Mammal Protection Act in 1972.

No one knows how many whales, porpoises, dolphins, or seals inhabited Maine waters in primitive times, but it's likely that they cumulatively numbered in the hundreds of thousands. We can only imagine what it must have been like to sail along our coast five hundred years ago and encounter the unsuspecting curiosity of the sea mammals of Maine.

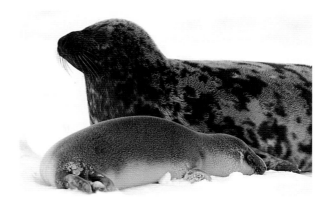

———————

Though rarely spotted, hooded seals (above) and harp seals (below) do occasionally venture as far south as Maine. These particular individuals were photographed in the Gulf of St. Lawrence during calving season in early spring.

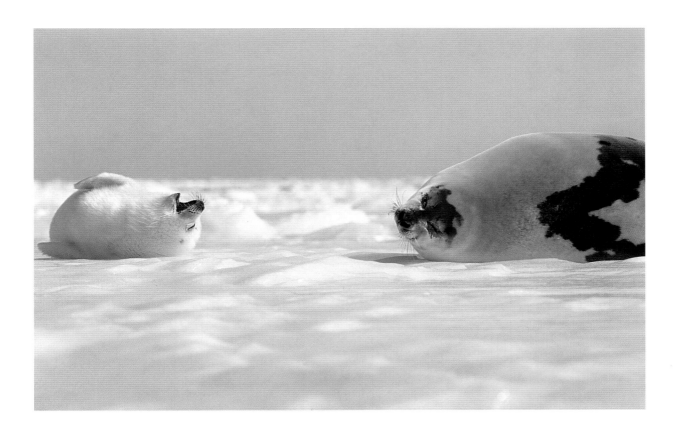

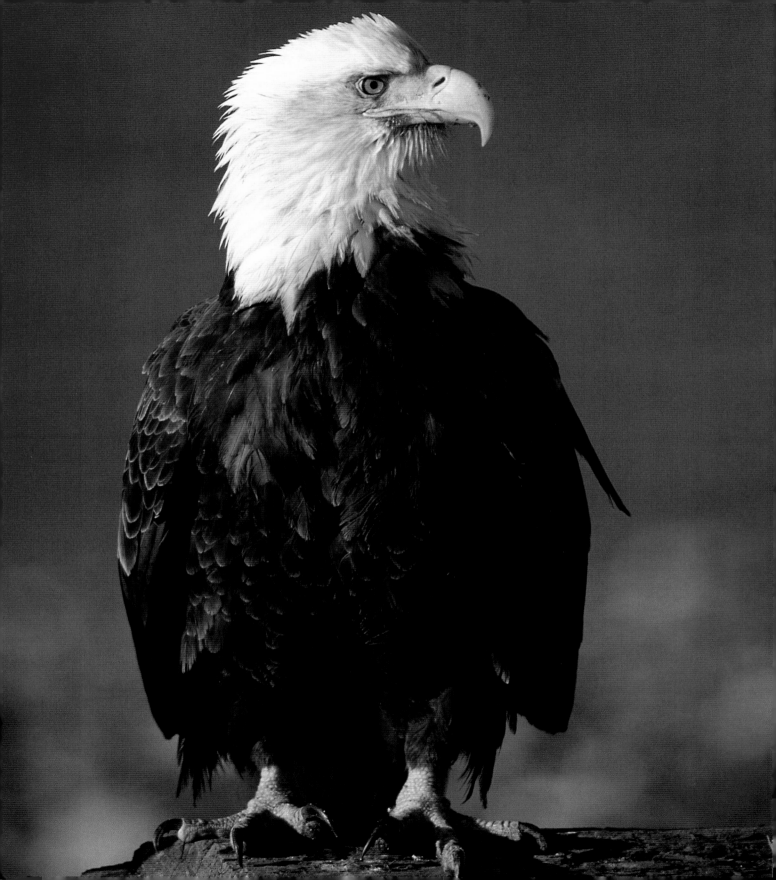

chapter thirteen

EAGLES FOREVER

The mainsail of the Maine schooner *Isaac H. Evans* makes a unique screen on which to project a slide show. The white canvas is translucent, so an image cast upon the sail shows with equal brightness on both sides. After Captain Brenda Walker dropped anchor in a totally dark Buck's Harbor one June evening, she left the windjammer's biggest sail up in the still night air so I could offer a program for her paying passengers.

I could have done a moose program, but instead chose to show images from *Just Eagles,* my book with author Alan Hutchinson. We placed the projector in the starboard-side dinghy to get it as far as possible from the angled mainsail so it would shoot respectably sized representations of bald eagles onto the makeshift screen. The setup worked fine, with folks enjoying the slide show from both sides of the sail.

At six o'clock the next morning, while drinking coffee on deck, I heard the unmistakable call of a bald eagle. Looking over my shoulder, I saw its nest in a tall white pine on shore, only about a hundred yards distant.

When asked if she'd known that the nest was there, Brenda shook her head. "It wasn't last year, and this is our first trip here for this season," she told me.

A biologist from the Maine Department of Inland Fisheries and Wildlife later confirmed that this was indeed a new nest.

Can you imagine what those birds thought that night when they saw the giant bald eagles on the sail as we lit up the quiet anchorage that served as their front yard?

THE EAGLES OF MAINE

Historically, both the bald eagle and the golden eagle nested in Maine. Early explorers and colonists reported seeing bald eagles throughout the state, including along many ocean bays and inlets, on several offshore islands, on larger lakes and ponds, and on the Kennebec, Androscoggin, Penobscot, St. Croix, and other rivers.

While nobody knows just how many bald eagles existed here in primitive times, the habitat was perfect for them. They would have prized the unlimited supply of tall white pines for nesting. And the abundant supply of fish and waterfowl found in Maine's waters easily supported many of these birds.

French adventurer Samuel de Champlain and others reported finding colonies of bald eagles when exploring the Kennebec River. Surely there were once hundreds, perhaps thousands, of them living in the land we today know as Maine.

Golden eagles, which are more adapted to the cliff-nesting environments found in western states, were probably never numerous here. Maine ornithologist Ora S. Knight described the golden eagle as "only a straggler" in his 1897 book, *Birds of Maine.*

Also in that work he detailed a fascinating account of finding two birds at Sandy Bay Mountain,

Bald eagles can be found throughout Maine in the vicinity of the coast, lakes, and larger rivers.

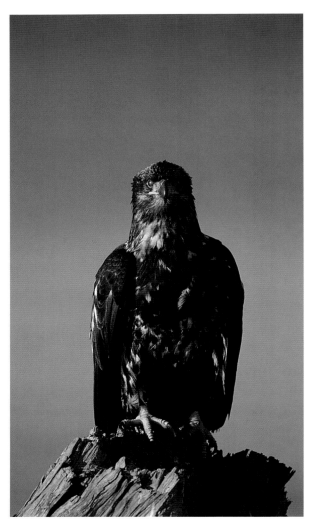

Immature bald eagles are darker than adults and may not acquire the distinctive white head and neck until they are four or five years old.

near Jackman, in 1895, birds that he and Professor F. L. Harvey from the University of Maine both took to be golden eagles. One of them swooped overhead:

> This bird was seemingly uneasy at our presence and flew very near us uttering its shrill cry. The cry was answered from a steep cliff on the side of the mountain, so the bird either had a mate or young in the immediate vicinity. While the bird repeatedly approached near enough to us to render us certain in our minds of its identity, we unfortunately had no gun with us, and so could not secure the bird to render its identity absolutely certain, as is demanded by modern science.

We should be thankful that the capability of optics and photographic equipment today preclude the need for such drastic measures in the name of science! But before you judge Mr. Knight and other ornithologists of his era too harshly, consider the sad story of the American eagle.

On June 20, 1782, the Second Continental Congress selected the bald eagle—found only in North America—as our national symbol. Not long after that, we declared war on these magnificent birds. We killed them for ceremonial feathers; we wasted them for sport; we shot them as rivals for food species we wanted all to ourselves; and we destroyed their nesting habitat.

Finally, we introduced massive quantities of a poison into their food supply. With the widespread use of the insecticide DDT after the late 1940s, we nearly eliminated the bald eagle from the planet. DDT washed into lakes, ponds, rivers, and streams. It

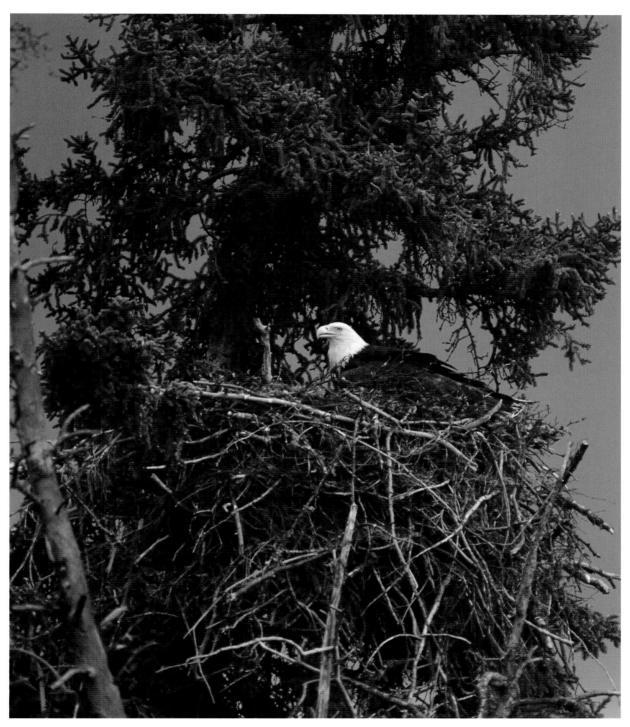

Nesting pairs usually return to the same site year after year, adding to their massive nest each season. (Some nests may weigh as much as a ton.) Eagles lay one or two eggs (rarely three), which hatch after an incubation period of thirty-one to forty-six days.

built up in the fish that eagles fed on. It accumulated in the bodies of the eagles, with a variety of harmful effects. Fragile and porous DDT-laced eggshells proved especially disastrous for the bald eagle.

From an estimated North American population of a hundred thousand birds in the early 1700s, humans col-lectively whittled down the bald eagle to the mere 417 nesting pairs found by researchers in all of the lower forty-eight states in the early 1960s. The low point for Maine came in 1967, when bald eagles occupied only twenty-one nests.

Thanks to Rachel Carson, however, the problems caused by DDT were eventually documented, and its use was banned in the United States in 1972. In 1978, in recognition that the species was vanishing, the bald eagle was listed under the Endangered Species Act in most of the lower forty-eight states, including Maine.

The bald eagle's recovery has been successful enough that in July 1995 it was downlisted to "threatened" status under the Endangered Species Act. Outside Alaska, the U.S. bald eagle population today numbers more than six thousand breeding pairs.

On average, 175 of those pairs have nested in Maine in the past five years. And a record 269 Maine bald eagle pairs raised 266 eaglets in 2001. Perhaps someday we will once again see whole colonies of bald eagles in wild Maine.

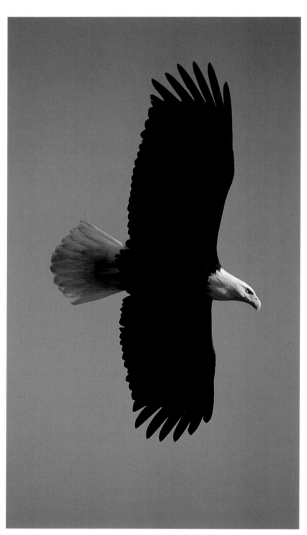

Eagles' primary food is fish, which they may catch for themselves or steal from other predators, such as ospreys, when the opportunity arises. They also will feed on rodents and even carrion.

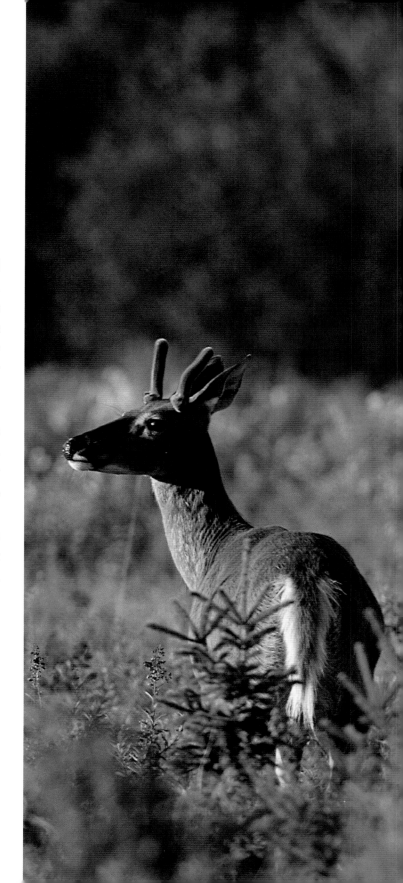

chapter fourteen

GRACEFUL WHITETAILS

Several coyotes howled close by the campground in the predawn that late-summer morning. From the direction of their calls, I had to guess that there were at least three of them. You can never be sure about coyotes, though; they seem to throw their voices, as a ventriloquist does, so counting them by their calls is always a gamble.

I wonder if the deer know that.

The intensity and the locations of the calls on this morning suggested that a number of coyotes lurked in the nearby woods. And so it seemed unlikely that any self-respecting prey species would show itself in the field by the campground.

That was too bad. The field at Nesowadnehunk Campground, in Baxter State Park, often offers a great opportunity to watch and photograph white-tailed deer that have little fear of humans. These deer seem to understand that the folks they meet here are "safe." While some might call that habituation, Percival Baxter, in giving to the people of Maine the land for the two-hundred-thousand-plus-acre park that bears his name, wanted it to be a home for wildlife. He wanted the animals to feel safe with people: "With the protection of wild life the deer, the moose and the

It is not unheard of for a mature whitetail doe to grow vestigial antler spikes, but it's a rare occurrence.

birds no longer will fear man and gradually they will come out of their forest retreats and show themselves."

As one who has seriously pursued these most graceful of North America's wildlife, my hunch is that their behavior is more influenced by how people behave around them than by how many people they encounter. Nonthreatening postures tell a wild animal a lot—as do threatening ones.

So does a predator call. Thus it was a surprise to see a fawn show itself in the field that early September morning.

The little skipper's sibling soon bounced into view too. While it's more proper to call them fawns, the term *skipper,* used by some old woods hands, really fits the demeanor of a young deer.

These youngsters still showed bright spots on their coats. The spots help fawns hide from predators. Scentless and well camouflaged, fawns often lie

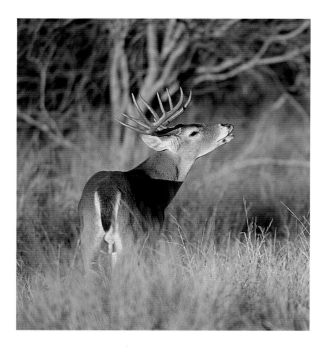

perfectly still when told to by their mother, even as a threatening animal approaches, searching for them.

These two skippers seemed unconcerned about showing themselves in the field. Perhaps they were relying on the greater predator-detection ability of what appeared to be their older brother, judging by its five-inch-long spike antlers.

Female deer, especially related ones, band together in small herds. Older "aunts" help oversee the youngsters. A yearling buck will sometimes hang around with his mother's herd until the pressures of emerging hormones change his life forever by the time his second fall season comes around.

This young buck was more cautious than the fawns, and he looked around the field often. He also kept at a distance that required me to use a telephoto lens to get good pictures.

It's always better to use a long lens when photographing wildlife, to avoid stressing even those which seem to feel safe around humans. I take my time about moving gradually closer even when the animals seem to feel comfortable with my presence. With whitetails, getting a bit closer can take as long as half an hour—or never happen. With this young buck, though, it took only five minutes.

Imagine my surprise when I at last got close enough to learn that older "brother" was really the fawns' mother!

While quite rare, antlered white-tailed does do occur. Biologists believe this anomaly results from an

After spending the summer alone or in bachelor groups, bucks seek out does in fall. The lip-curling flehmen behavior exhibited by male deer (and other ruminants) allows them to better detect the scent of an estrous doe.

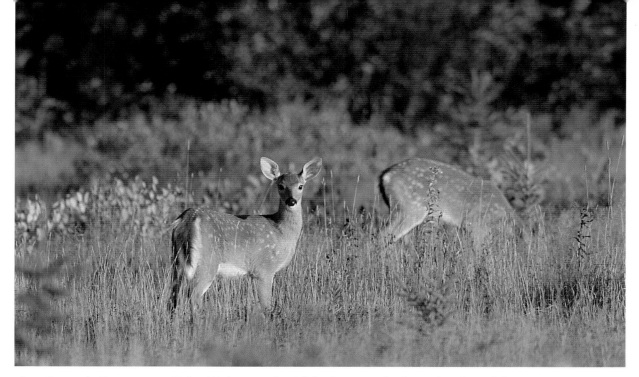

According to the Department of Inland Fisheries and Wildlife, the average birth rate for whitetail does in Maine is 1.3 fawns per year, but only 60 to 80 percent of those offspring survive past their fifth month.

excess of testosterone that displays itself through antler growth. The short spikes that such females produce do not shed the "velvet" that nurtures antler growth, but remain encased in it. And—as evidenced by this encounter—these antlered does can reproduce.

THE WHITETAILS OF MAINE

White-tailed deer are near the northernmost limit of their range in Maine. Early European explorers and settlers to the region reported an abundance of deer in the forests and at woodland edges. The whitetail provided an important source of food and clothing—as well as tools made from antler, hoof, and bone—for the Native American tribes that lived here for centuries before that.

The apparently inexhaustible supply of wild animals that the first European explorers to the New World found here led generations of folks to take these wildlife resources for granted. The history of North America is replete with such examples, and one of the worst involves the white-tailed deer. There were so many, estimated to number anywhere from fifteen to forty million across the continent, that hunting was largely uncontrolled until the late nineteenth century. By then, whitetails had become scarce in many places: Massachusetts, southern New Hampshire, Vermont, Connecticut, New York, Pennsylvania, and much of the Midwest. Only the northern forests of Maine provided a real haven for this species. The exploitation was such that naturalist Ernest Thompson Seton

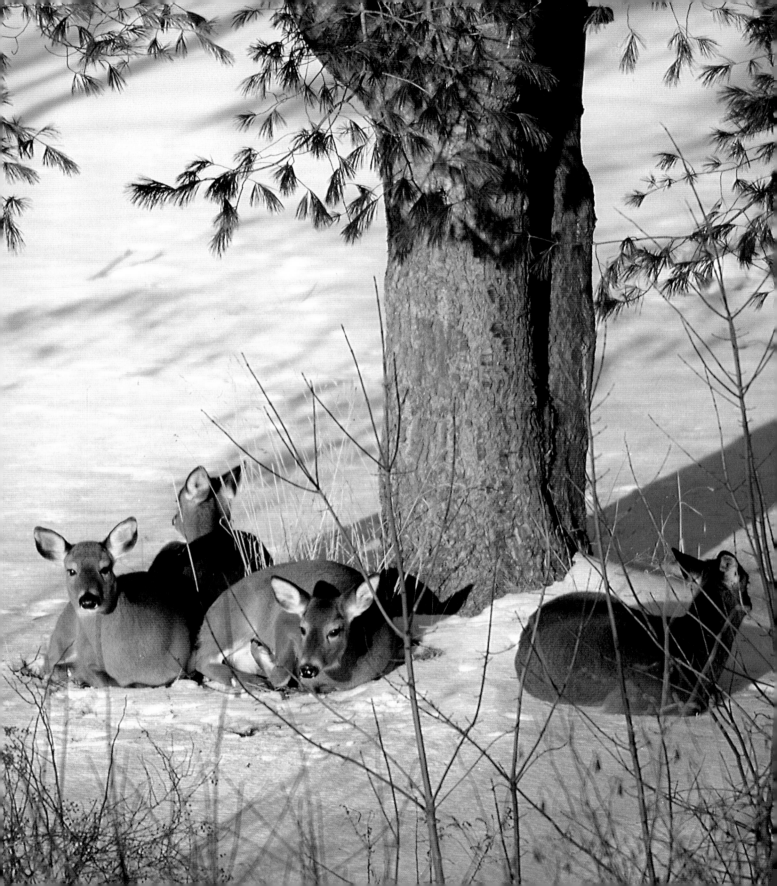

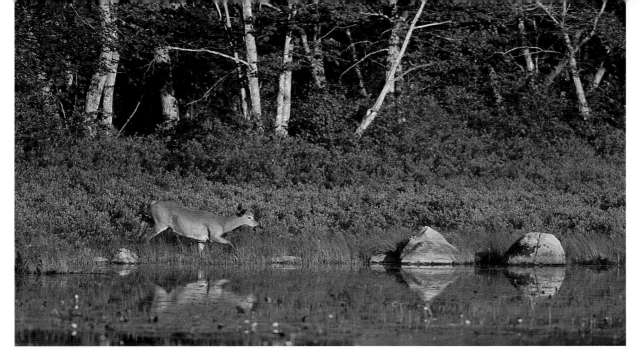

Whitetails can reach speeds of forty miles per hour on land. They are strong swimmers as well, which explains why deer populations can be found on Maine's larger islands.

would write in the early 1900s: "In 1890, the Whitetail was virtually exterminated in New England, outside of Maine."

Even in Maine, where Seton conservatively estimated the deer herd at some 75,000 in 1906, the numbers represented a remnant of what once existed. Deer needed better protection, as did all other game animals at that time.

With the eventual advent of game laws, closed seasons, a progressively better warden service, and more enlightened wildlife management throughout the twentieth century, the deer herd in Maine has rebounded in many areas, with a 2002 statewide population estimated by the Maine Department of Inland Fisheries and Wildlife at 241,000 animals.

In fact, some consider deer a nuisance today, as local overpopulations result in the destruction of ornamental shrubs and even forest habitat. Deer are hosts for the tick that carries Lyme disease. Roaming deer also can be a traffic hazard.

Have those who say that we should combat such problems by eliminating all the deer lost touch with the natural world? Don't we owe it to future generations—and to the deer themselves—to learn how to better coexist so we can continue to enjoy the sight of these most graceful of creatures, which help keep the wild in so much of Maine today?

———————

In preparation for winter, deer grow a thick, insulating coat of fur and also build up body fat—as much as 10 to 25 percent of their total body weight. Once snow falls, they seek shelter in dense stands of mature conifers.

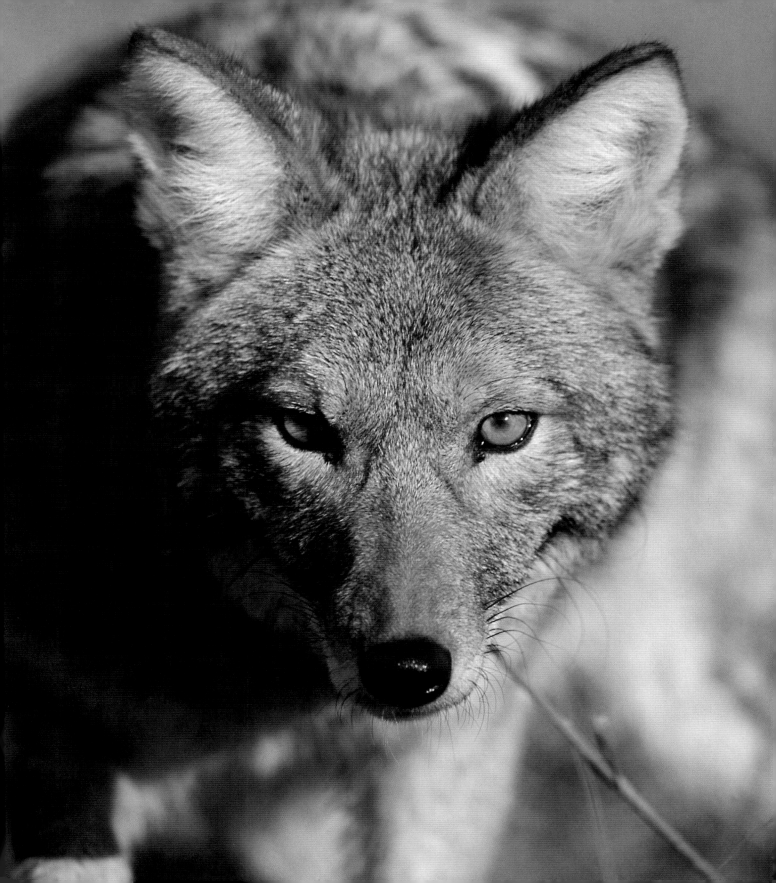

chapter fifteen

SOME NEWCOMERS

Talking to moose is a specialized skill. Imitating the vocalization of a cow during the rut requires time spent listening to the real thing and demands a bit of practice. The ability to duplicate it by mouth alone, without the benefit of a manufactured mouth call—or even one homemade from a No. 8 can and rawhide string, as was employed by some old woodsmen—is a rare skill indeed.

Cow moose only make this particular call during the few days that they come into estrus during the short moose rut. Even serious moose watchers don't get much chance to develop either an ear for this call or an ability to imitate it.

That's probably why the distant sounds mimicking the wailing cow calls I'd made myself just a few minutes earlier one September afternoon sounded bogus. This human imposter obviously hadn't heard the call of many moose cows in estrus. I laughed after the unseen moose impersonator made a third feeble attempt to get a bull moose to show itself.

But my laughter stopped when the imposter switched from practicing what were probably first attempts at duplicating a new sound into one that this wannabe moose mimic knew quite well: the primeval howl of a coyote. Those off-key sounds coming from the woods west of the pond had not been human efforts at all. This was a four-legged predator practicing *its* rendition of *my* cow moose mating calls!

THE NEWCOMERS TO MAINE

Most authorities consider the eastern coyote to be a recent arrival to Maine, one that filled the void left by the eradication of the eastern timber wolf by the late 1800s. The Maine Department of Inland Fisheries and Wildlife reports coyotes as returning to Maine at least by the 1960s, and some people claim that they arrived here as early as the 1930s.

But these animals, weighing from thirty to forty-five pounds, are significantly larger than the western coyote. Some researchers think that the eastern coyote

The typical eastern coyote is larger than its western cousin but every bit as clever and adaptable. The Maine Department of Inland Fisheries and Wildlife identifies two small subcategories of coyotes in the state. One group has a genetic makeup more similar to that of western coyotes; the other exhibits more wolflike characteristics than do most eastern coyotes.

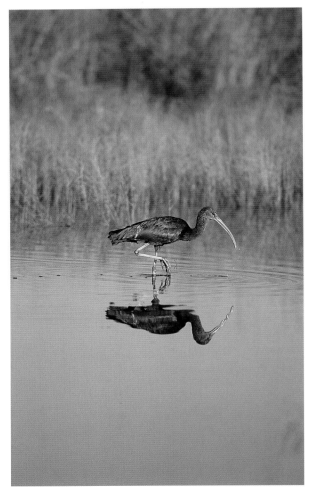

Originally an Old World species, the glossy ibis was first recorded in North America in 1817. It expanded its range very slowly (earliest North American breeding records date from the 1880s). During the 1940s the birds were breeding as far north as New Jersey. By 2000, however, even southernmost Maine was included in its range.

may have migrated to Maine from either Canada or other northern states. Others wonder if the larger animals may be part wolf or descended from wolves. And still others hypothesize that the wolf may have originally been a descendant of the coyote! More definitive information is now being sought through DNA testing.

In view of all this controversy, it's fascinating to note the statement by John Josselyn, the early English naturalist who spent a number of years at Black Point in Scarborough, from his 1672 *New-England's Rarities Discovered:* "The Indian dog is a Creature begotten 'twixt a Wolf and a Fox, which the Indians lighting upon, bring up to hunt Deer with."

Suburban-dwelling folks probably don't even think about coyotes unless their cat is missing. But some Mainers hate coyotes. Those who dislike them include a number of hunters who enjoy the pursuit of white-tailed deer. Coyotes work the deer herd hard. In Maine's big woods, spruce budworm devastation in the 1970s and past logging practices have resulted in diminished winter deeryard habitats with a protective canopy of thickly growing softwoods that limits snow depth. Where there are only marginal deer wintering areas, predation takes a greater toll.

Others say that predators are part of the natural world, and if that world gets out of balance, perhaps we need to look harder at ourselves for the answers, rather than blaming the animals.

Whether you like them or not, and no matter when they got here or even what they are exactly, one thing is certain: Eastern coyotes are here to stay. Biologists estimate that at least ten thousand individuals, and perhaps as many as sixteen thousand, live in Maine as of this writing.

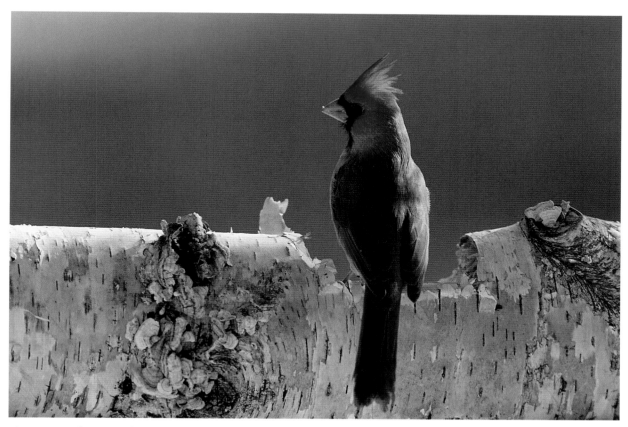

A warming climate and well-stocked bird feeders are credited for the increasing numbers of cardinals seen in Maine in recent years.

Some noncontroversial species have also begun to spend at least part of their year in Maine in recent times. Turkey vultures, mockingbirds, cardinals, titmice, glossy ibis, and Carolina wrens come to mind. Have they, as the coyote did, taken advantage of a vacuum left by the demise of a former native species? Or has climate change permitted—or driven—these species to become part of wild Maine?

———————

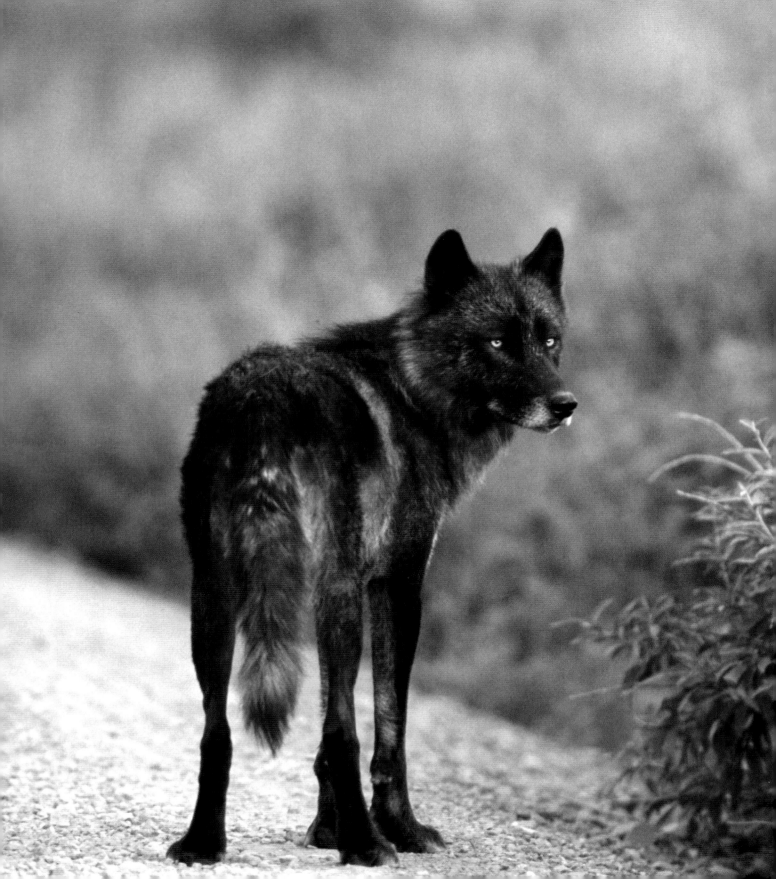

chapter sixteen

GONE BUT NOT FORGOTTEN

The black wolf stood on the side of the road and looked back over its shoulder at something in the thick brush that grew right up to the edge of the gravel road. Its yellow green eyes glinted in the early morning sun as it peered into the vegetation, ears erect and scanning for the source of the sound it had detected. It seemed quite unconcerned with the two people kneeling beside the pickup truck only a hundred feet away.

That's when the hidden wolf yipped softly.

The wolf in the road whined back a message. The unseen one answered with another muted sound.

These gentle communications were not what I'd expected from an animal as reportedly fearsome as the wolf. Aside from the thrill of sighting of this elusive animal, what was so fascinating about this rare encounter was that neither wolf made sounds worthy of this predator's reputation in legend and lore. Their calls were more the whines and whimpers of a couple of dogs talking to each other.

And that made me wish—not for the first time—that I could carry sound-recording equipment while working in the wild as another way to capture what is still out there.

At least I had the pictures this time.

THE DUSTBINS OF MAINE

The encounter described above happened in Alaska—not in Maine. No known reproducing population of wolves exists in the wild in our state today. Historical references suggest that wolves were once numerous in Maine, and the Harvard Museum has a wolf skull from the state as evidence. John Josselyn, the English adventurer and early chronicler of wild New England, wrote in 1672 of two kinds of wolves, "one with a round ball'd Foot" that were "in shape like mungrel Mastiffs," the other with "a flat Foot, these are liker Greyhounds and are called Deer Wolfs, because they are accustomed to prey upon Deer." Whatever these canines were exactly, they were eradicated by the late

(above) Today our only reminders of the once unimaginably large flocks of passenger pigeons are a few drab mounted specimens.
(left) The gray wolf was extirpated from the Maine woods—but perhaps has returned, according to anecdotal evidence.

93

1800s. Like a number of other species that once inhabited Maine, the eastern timber wolf no longer roams here.

Or does it? A bear hunter shot a wolflike creature in the Maine woods in 1993. Employing the science of crime fighters, DNA experts declared that it was indeed a full-blooded wolf, and biologists from the Maine Department of Inland Fisheries and Wildlife speculated that someone might have released it here. They also said that it was possible but highly unlikely that the animal had wandered in from Quebec, which still has a remnant wolf population. Perhaps only that wolf knew for sure.

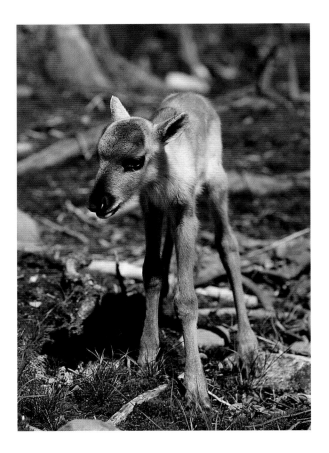

While we do not know whether wolves might really return to Maine, we do know about the fate of some other species.

Consider the passenger pigeon. Josselyn wrote in 1674 of seeing a flight of "Pidgeons" that extended four or five miles—so wide that he could see no "beginning or ending, length or breadth, and so thick that I could see no sun."

It took only two centuries of uncontrolled harvesting, mostly done by netting these birds in flocks, to wipe the out the species. As Maine ornithologist Ora W. Knight wrote in 1908,

> Of the hordes of Passenger Pigeons which formerly passed through the State in large flocks and nested abundantly within the memory of scores of people now living, none remain now. All have left us. While practically the last birds disappeared somewhere about 1885, a few stragglers were occasionally taken until what seems to be the last Maine specimen recorded was taken at or near Dexter by Frank Rogers, August 16, 1896. The birds formerly nested by the hundreds in hardwood growth, placing their nests by scores on the trees…. If not now extinct throughout the entire United States its extinction is not far distant. Netted by the millions, met by destructive man at every feeding and breeding place, is it any wonder that the countless millions of the past are with us no longer?

A woodland caribou calf photographed in Orono in 1990, during the ill-fated reintroduction project.

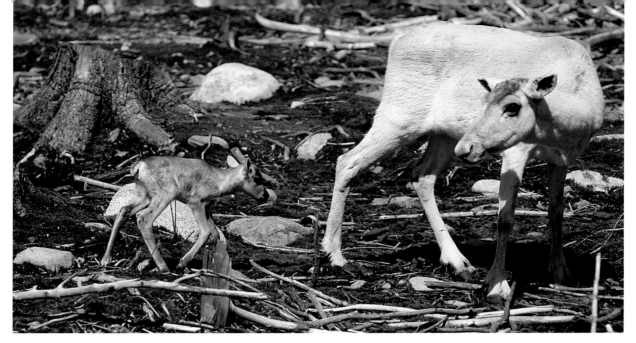

A caribou cow and her calf. Many of the reintroduced animals succumbed to a parasite that is endemic among white-tailed deer.

In fact, the only passenger pigeons left in the world today are stuffed ones—mounted specimens that show what this extinct species once looked like.

Other species that once inhabited Maine and are also gone forever from the planet include a large flightless relative of the puffin known as the great auk, the Labrador duck, the sea mink, and several less glamorous species similarly exploited to their ultimate extinction.

We have learned that we can cause the demise of a species. We have also learned that we can help a species survive. When we look at the story of the bald eagle's recovery in Maine, we find hope.

But can we do the same for other species? What of such creatures as the wolf or the mountain lion, both eliminated from Maine but surviving in other wild places? Can we bring them back to make an even wilder Maine? *Should* we?

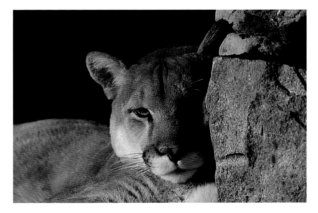

This mountain lion resides at the Maine Inland Fisheries and Wildlife visitor center. The suggestion that least a few of its brethren are again inhabiting Maine's wildlands sparks heated controversy today.

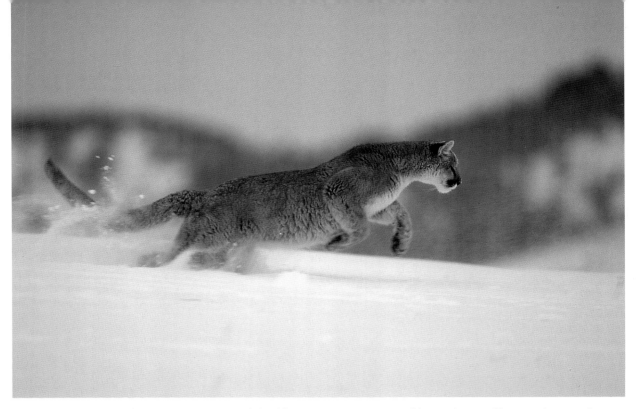

Some people are convinced that Maine can, and should, once again support a stable population of large predators such as the wolf and the mountain lion. They argue that by reintroducing these missing pieces to the Maine "mosaic" we will enrich not only the ecosystem but our own spirits as well.

While there have been some notable successes—puffins and turkeys, for example—bringing back a species that has been extirpated is not at all easy. In the past fifty years, two failed attempts to reintroduce the woodland caribou proved this. And so we have also learned that it's a lot better to prevent extirpation to begin with.

Those who today advocate the reintroduction of the timber wolf to Maine's big woods claim that adequate habitat and food exist to permit the wolf to again take its place in the grand mosaic. Others, including sportsmen who pursue the same prey species that Maine wolves would, especially moose and deer, are not so sure. Still others think that we should let nature take its course in such matters: If the wolves come in on their own, as may actually be the case, let them.

Will Maine someday enjoy an even greater diversity of wildlife? Perhaps. We may see the return of the caribou, the cougar, and the wolf. One thing is certain: We are fortunate to enjoy the many species of wildlife that still frequent our state. With continued vigilance and thoughtful management, we can pass on what remains of Maine's once grander mosaic so that future generations won't have to rely on their dreams to know what wild Maine was really like.

———————